#NOFILTER

LAURENCE KING

Published in 2019 by
Laurence King Publishing Ltd
361–373 City Road
London EC1V 1LR
United Kingdom
email: enquiries@laurenceking.com
www.laurenceking.com

A catalogue record for this book is available from
the British Library

ISBN: 978-1-78627-407-6

Design: Mariana Sameiro
Vector line drawings: Akio Morishima

Printed in China

#NOFILTER

Get creative with photography

Natalia Price-Cabrera

Laurence King Publishing

Contents

Introduction

With our cameras in our pockets we are all photographers, and the built-in creative functions on our apps and on social media mean we can edit and share on the go. However, such image-making is by its very nature loaded with limitations, and there is now a palpable backlash against the ubiquitous mindset of 'click, add filter, post'.

Photography doesn't have to be so transient and throwaway, and there is so much more fun to be had with it. *#NoFilter* is for anyone who wants to take their new-found creativity beyond the touch of a button. Replete with ideas for new techniques, processes and subjects to try, this book is a source of inspiration for image-makers of all abilities, illustrated with incredible work by photographers from all over the world who are pushing and developing their artistic boundaries. The scope of projects featured is vast, and you will discover work that innovates while applying traditional shooting, processing and printing techniques; ideas that involve hacks and makes; work that combines media; and images that arrest and inspire the reader in equal measure.

The power of photography is boundless. It can beguile, revolt, intrigue, record, invent, flatter, sell, tell a story or create artifice. A photograph is often the result of a fleeting, spur-of-the-moment reaction to something, or a lengthy, deliberated construct that has involved hours of thought and preparation. However, the act of 'capturing the moment' is not always the end goal. There can be infinite processes thereafter that the photographer ruminates over, whether that is how to print the image or in many cases how to deconstruct it. There is no wrong or right approach. So get ready to be creatively stimulated as you turn the pages of this book and let the images and ideas contained within springboard your own image-making imagination. Have fun!

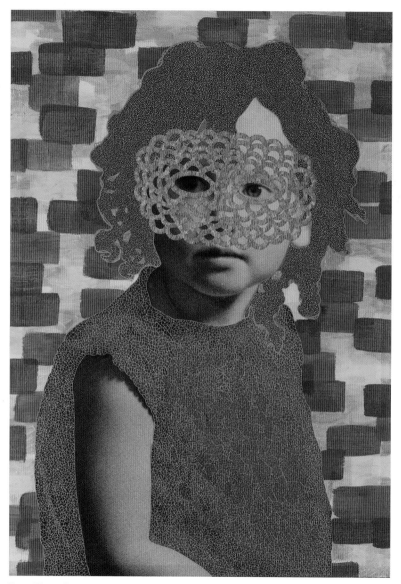

Naomi Vona, *Fortuna*

Cut, stick and glue

Make a photo collage from your stationery cupboard

● ○ ○

Why not experiment with coloured pens and washi tape to selectively obscure parts of existing images you might have? This is exactly what Italian artist Naomi Vona does. With the use of fluorescent pens, stickers, washi tape and glue, Naomi teleports her collection of black-and-white vintage images into a psychedelic fantasy future world that leaps out at the viewer. You can use your own images or trawl jumble sales and second-hand shops for old photos and postcards to overhaul with a 'face lift'.

Naomi's signature decorative mark is a crochet-effect eye mask (as seen opposite), and the artist considers herself a photo and video archival parasite – but in a good way! 'I draw portals on old photos because I believe that in some way they can allow me to travel in time and space.'

You will need:

a photograph or a postcard, fluorescent marker pens, washi tape, stickers, acrylic paint, glue

Bill Armstrong, *Unspoken #1502*

What do you see?

Defocus an image to create blur and soft edges

● ○ ○

By deliberately defocusing an image you can bring into question exactly what it is the viewer is looking at. To create this image, Bill Armstrong assembled a collage from a wide range of sources, spanning pop culture to art history, and then subjected them to a series of manipulations, such as photocopying, cutting, painting and collaging, before photographing his construct.

To achieve the defocused look, Bill subverts the photographic norm, shooting close up, but with his focus manually set at 'infinity'. As a result, the edges of the collaged elements disappear, and the blurred photograph takes on the appearance of seamless, integrated images. 'This sleight of hand allows me to conjure an illusionistic *trompe-l'œil* world that hovers between the real and the fantastic. It is a world that might exist in memory, in dreams or, perhaps, in a parallel universe yet unvisited.'

You will need:

camera, source images,
paint, scissors, glue

Do it your way

Bill creates his subject matter using collage, which is a great way of tightly controlling what it is you are photographing; if you can collage it, you can shoot it. You do not need to go to these lengths, though, as the technique also works in the 'real world'. Simply set your camera to manual focus and change the focus point to determine the level of blur.

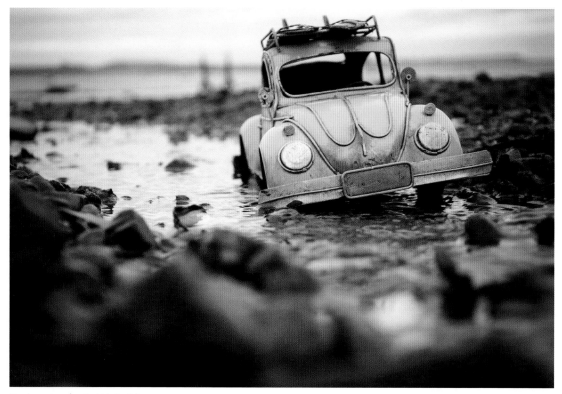

Kim Leuenberger, *An Irish Puddle*

Scale down

Deceive the eye with a miniature scene

● ○ ○

You do not need elaborate sets and lighting to create a scene that resonates with a visually savvy audience. Great things can be achieved with very little equipment, as Kim Leuenberger's *Travelling Cars* series proves.

The premise is simple: Kim travels the world with her collection of diminutive cars and stages them in the most idyllic of scenarios, combining her love of retro cars and her never-ending thirst for adventure. In her fantastical vignettes a puddle can become a lake, a trickle of water a stream, and a rock can transform into a mountain.

Shooting exclusively with prime lenses (typically 24mm, 35mm, or 50mm), Kim exploits their wide apertures to capture her images. 'I love the blurriness in the depth of field because I find it comforting. I usually rest the camera on the floor or on my foot to capture it low to the ground!'

You will need:

camera, toy car

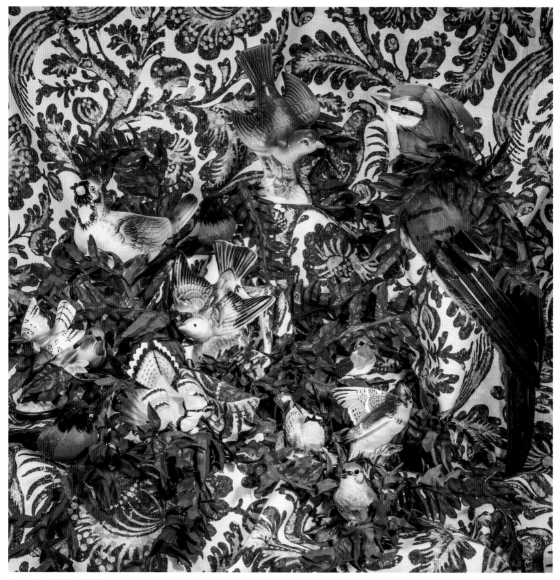

Patty Carroll, *Blue Bird*

Tweet tweet

Create a fantasy scene using household objects

● ○ ○

Photography can be used to record all manner of staged scenes, be it created in 'real life' or manipulated digitally. Patty Carroll's highly decorative still-life series *Flora and Fauxna* features bird figurines photographed against vibrant colourful backdrops. 'I use decorative fabric, artificial flowers and household objects to create a sumptuous, ornate world,' explains Patty. 'This world mirrors the home life of birds in nature, while symbolizing the nesting instincts of women whose homes are a sanctuary of pride and obsession.'

 Patty's still-life images were set up in a studio, lit with small studio strobes, and shot with a Hasselblad digital camera – a tripod was essential for holding it steady. The only manipulation involved was to the colour and sharpening before printing; everything else was achieved in-camera.

You will need:

subject, flash or continuous lighting, camera, tripod (essential), reflectors (optional)

Do it your way

With a bit of care, you can create similar results on your kitchen table using the light from a window or from one or two desk lamps – you don't necessarily need a full-blown studio and large strobes. Use pieces of white card (carefully placed out of shot) to bounce the light back into any dark shadows.

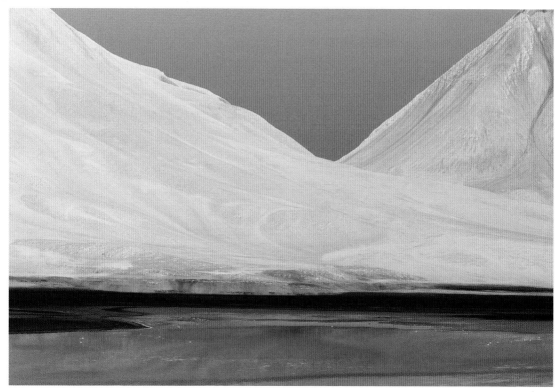

Brendan Pattengale, *Your Love and Light*

Through the looking glass

Use mirrors, glasses or binoculars to distort reality

● ○ ○

Throughout photography's relatively short history, artists have searched for ways to distort reality. One option is to use a range of optical 'tools' to alter the image: hand mirrors are great for introducing distortions, binoculars can shift perspective, and sunglasses with coloured lenses can be used to change the colour of the world around you. Play around with the angle of a mirror in front of your lens and photograph the reflection on it or photograph your scene through binoculars and/or a pair of sunglasses; experiment with different ways of interpreting the world.

Brendan Pattengale is a photographer with a painter's eye for colour and composition, who sees the camera as a glorified paintbrush. As a frequent traveller, he seeks out uniquely beautiful landscapes to suit his otherworldly aesthetic, cleverly achieved using mirrors; red lakes in the middle of Bolivia and the mountains in Iceland can equally appear as if someone daubed them with a giant paintbrush loaded with every colour imaginable.

You will need:

camera, binoculars, assortment of hand mirrors, sunglasses with coloured lenses, imaging software

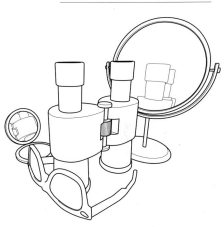

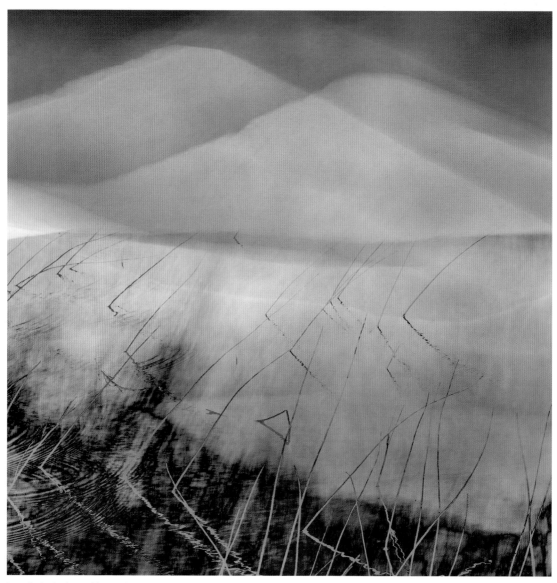

Lynn Fotheringham, *Glimpse 1*

Layered landscapes

Create ethereal images using multiple exposures

● ○ ○

Lynn Fotheringham's ethereal landscapes are created using multiple exposures to 'capture the essence of the landscape at a particular moment; the movement of the weather, the hill shrouded in cloud'.

Multiple exposures can be made in-camera, as detailed on the following pages, but Lynn's digital SLR is relatively simple, so she layers her work in Photoshop instead. 'I don't use Photoshop for editing, only for layering. For editing I use Lightroom, which seems more authentic to me, because you are essentially making the same alterations to the image that you would make in a traditional darkroom; there's no cutting, pasting, masking, or swapping of skies and other elements.'

Lynn combines images that have been made within seconds of each other – sometimes using intentional camera movement (ICM) to introduce an added textural quality – and although her work is abstract, she pays close attention to focus and the direction and quality of light to create 'a sense of the landscape rather than an "accurate" record'.

You will need:

camera, editing
software with layers

Multiple exposures

Whether you shoot on film or capture your frames digitally, there are numerous ways in which you can create your own stunning multiple exposures, both in-camera and post-exposure. The only real limitation is your creativity. Here's a rundown of the options open to you, and their pros and cons.

In-camera: digital

The main reason multiple exposures are so popular right now is that a growing number of digital cameras make the process really simple. In many cases you just have to activate multiple exposure mode, set the number of shots you want to combine, and snap away: the camera will take care of all the complex exposure decisions for you and let you preview the combined shots as you go.

Some cameras offer creative options that let you control how the images are merged, with priority given to light or dark areas, or to ensuring that your highlights don't blow. There's no single path here, so check out your camera manual to see what's on offer and then start experimenting.

In-camera: film

Shooting multiple exposures on film isn't easy. You will need a camera with manual exposure control and the ability to cock and fire the shutter without having to wind on the film (medium- and large-format cameras tend to be the best option here). You also need to be able to visualize how your individual shots will combine and work out the exposure. The simple rule of thumb is that subsequent exposures show up most in the darker areas of the preceding image, so if your first shot has a lot of white in it, your second shot won't have much effect. You also need to bear in mind that the exposures are cumulative, so it's easy to overexpose the final shot. To avoid this, underexpose each shot by 1 stop (if you're combining two shots), by 2 stops (for four-shot combos), and so on. It also helps to shoot on negative film, as it is more forgiving to exposure errors.

Combining negatives

You can create multiple exposures in the darkroom by combining negatives. The simplest way to do this is to load two or more negatives into the carrier on your enlarger, so you can see the combination on the baseboard and test/print it as you would any other negative. The downside is that the density of the combined negatives will make your exposure times longer than usual and it can be harder to control the contrast. As an alternative, think about exposing the negatives one after the other, either swapping them in the enlarger or – if you have the option – by using multiple enlargers and moving your paper between them to make your different exposures.

Computer combinations

Editing software makes it super-simple to combine multiple images. Using layers you can adjust the opacity of individual shots; change the colour, contrast and the way they blend; apply filters; and employ any number of other tools to create a pixel-perfect image. The problem is, this approach is so easy that it loses a lot of its credibility and can easily drift from the realm of photography into design or computer art.

Regardless of which technology you use, multiple exposures allow you to create images that would otherwise be impossible to capture in a single frame.

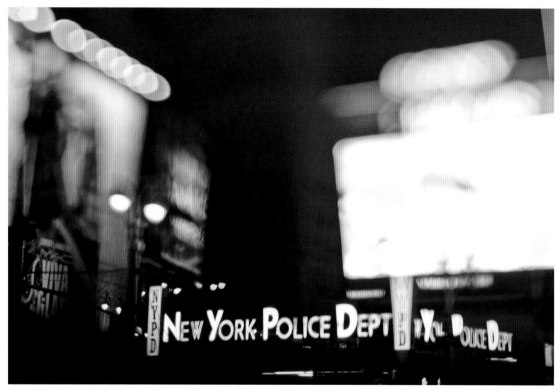

Daniel Lih, *New York Police Department*

Freelensing

The poor man's tilt-shift lens

● ○ ○

Often referred to as 'the poor man's tilt-shift lens', freelensing is a technique that can be used with both film and digital interchangeable-lens cameras. The process involves detaching the lens from the camera and holding it in front of the lens mount while you take a shot. This allows you to tilt or shift the lens as you see fit, altering the plane of focus and producing a result that is similar to a commercial tilt-shift lens, albeit with greater imprecision. As well as enabling you to play around with selective focus, you will also suffer degrees of light leakage, which can create extremely atmospheric imagery.

The photograph shown here was taken in New York City, but instead of documenting his first visit in a conventional fashion, Daniel Lih set about recording the essence of the place at night. He took this shot using a Nikon D90 mounted on a tripod, holding his 50mm prime lens in front of the camera and experimenting with its angle and distance until he got the focus he was after. There is no exact science to freelensing, so patience is essential, but that's part of the beauty of it: no two shots will ever be the same.

You will need:

interchangeable-lens camera (film or digital), 50mm prime lens, tripod (optional), patience

Marcus DeSieno, *A photograph of the Medusa Nebula eaten by bacteria found on a mirror inside a Sephora makeup store*

Eat your photos

Create special effects with the contents of your kitchen cupboard

● ● ○

It would seem counterintuitive to purposely destroy your film, but this is exactly what artist Marcus DeSieno does, with spectacular and unpredicted results. In his series *Cosmos*, Marcus applies a layer of chemistry to the film's surface, which acts as a breeding ground for bacteria he has collected from various locations. As the bacteria grow and multiply, they interact with the film, altering it, stripping away colour layers, and slowly disintegrating the archaic media into an unpredictable abstraction of colour and texture. He then scans the bacteria-laden film in order to create the final prints and – in the process – kills this microscopic ecosystem.

You can perform similar experiments with your own film, although you don't necessarily need to use bacteria. Instead, open up the cupboards in your kitchen or bathroom and see what chemicals you have that could be used to 'eat' your images; bleach and paint stripper are obvious choices, but other cleaning products, acids (vinegar) and other substances can all be experimented with. Just be sure to work in a well-ventilated area (or better still, outdoors) and wear appropriate protective clothing, which should definitely include goggles and gloves.

You will need:

a film image,
household chemicals

Frances Berry, *Lines We Live By*

Scanography

Use scanners and apps to create cameraless photography

● ○ ○

Finding herself increasingly disillusioned with the process of photography, Frances Berry took a radical step and sold all her cameras. She now uses a variety of technologies to create her 'cameraless' photographs.

Borrowing from the vast library of images she has built up, which form her source material, Frances creates digital collages by duplicating, pasting and moving elements around. She will then print the collage out and either take a picture of it with her phone or scan it, before continuing to 'push and pull' the image between devices until she considers it finished.

As she explains: 'I might edit something in Photoshop, open it on my phone, run it through an image-processing app such as Glitché, and then put it back into Photoshop, or I might print it out, scan it back in, and open it up in another app.' Keeping her original image moving between different devices and apps means her process is constantly in flux, and prevents her images from becoming repetitive or formulaic.

Do it your way

Play with your own photographs until you are happy with the results by applying filters and tools from different apps, and printing and scanning or rephotographing the image to add the textures of the technologies you use, such as inkjet dot patterns or laser printer lines.

You will need:

computer, image-editing software, smartphone (and apps), scanner, printer

Daniel Gordon, *Fish and Forsythia*

3D collage

Combine papercraft and photography

● ● ○

Daniel Gordon constructs highly elaborate three-dimensional still-life scenes out of paper, which he then photographs against graphic backdrops and prints out at a huge scale. These signature 'constructed tableaux' are painstakingly handcrafted, using hundreds of images made by Daniel himself or found online. To try his method, follow these steps:

1. Select and cut out your found image. Set up your tabletop 'stage'. Cover it with a bold printed piece of fabric or paper. Use wallpaper offcuts or wrapping paper glued onto card for the backdrop.

2. Stick each found image onto card and cut out – you can use a cardboard tab to stand the pieces up. Arrange your still life on your stage. You can add height to different elements by wrapping boxes to act as plinths.

3. Once you are happy with your still life, set up your tripod and shoot away. You can then upload your images to a computer and manipulate them as you see fit with image-editing software.

You will need:

camera, tripod, cut-out images (made yourself or found in magazines and newspapers or online and printed out), wallpaper offcuts, cardboard, glue

Mario Rossi, 3×5

Fun with timelapse

Photographing the same scene at different times

● ○ ○

Mario Rossi's work hinges on geometry and what he perceives to be a harmonious composition. The Italian artist will visit a location multiple times and take many shots from the same vantage point.

Recording the same scene over and over again at varying times is a challenging project, but one that can be incredibly rewarding. Knowing how to present your findings can be tricky, but a gridlike structure works well; Mario thinks of his work in terms of mathematics and music and his compositions are arranged in patterns that have obvious musicality to them.

You will need:

camera, tripod

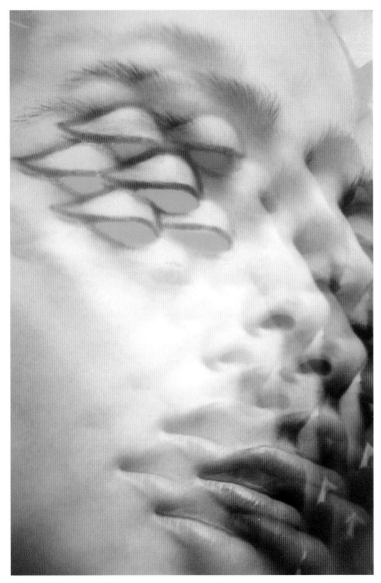

Elena Kulikova, *Electric Vision*

Bug-eyed

Distort your image with a makeshift lens

● ○ ○

Virtually anything that has a degree of transparency can be used to create a unique improvised lens: bubblewrap, drinking glasses, crystals, even a glass of water can all be used as a makeshift lens to shoot through.

Fascinated by a child's 'bug's eye' plastic filter in a museum shop, model-turned-photographer Elena Kulikova bought one and then photographed a series of portraits through its 'compound eye'. All the effects were achieved in-camera, apart from the eyes, which were painted over in Photoshop to make them a more graphic solid blue colour.

This technique can work just as well with digital or analogue cameras, and if you look around your home you will likely find plenty of plastic and glass 'filters' that you can transform into temporary lenses; just hold or stick them in front of your regular camera lens and shoot through them.

You will need:

camera, some kind of plastic or glass filter

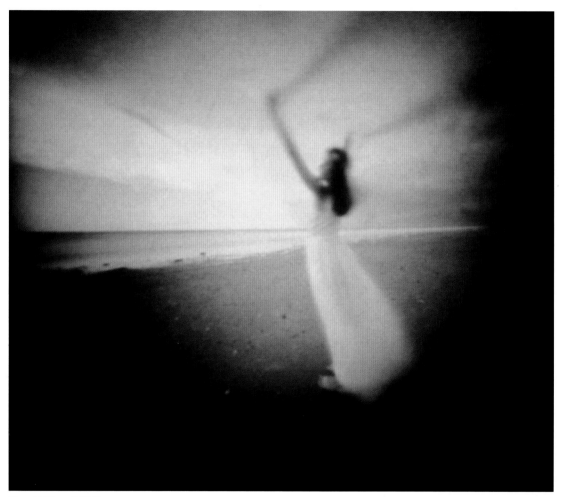

Diana H. Bloomfield, *Streamers*

Pinhole magic!

Take lens-less photographs using this ancient technique

● ● ○

Photographer Diana H. Bloomfield embraced pinhole photography because of its 'skewed perspective, its sense of movement and fluidity, and the feeling that you're looking at a dreamscape. I like to think of these as visual vignettes that suggest half-remembered, fragmented dream worlds. They borrow from the past, my ever-changing memories of that past, and fleeting moments in time. I have always felt the downside to still photography is that it is, in fact, so still.'

A pinhole camera is the most basic of cameras, essentially comprising a light-tight box with a small pinhole aperture in one side (details on how to make your own pinhole can be found on the following pages). Light from a scene passes through the small hole and projects an upside-down image on the opposite side of the box, which can be recorded onto photographic film or paper. For this image, Diana used a wide-angle Leonardo 4×5 pinhole camera and shot on black-and-white sheet film. The image was then 'cross-printed' on Arches Platine watercolour paper as a cyanotype over platinum/palladium, which created the unique split-tone effect.

You will need:

pinhole camera or pinhole lens for an analogue or digital interchangeable-lens camera

Pinhole photography

Virtually any light-tight container – or any container that can be made light-tight – has the potential to be transformed into a pinhole camera. Pinhole photographers have exploited a wide array of high- and low-tech solutions, from a simple matchbox to the back of a panel van.

If you're getting started, a small metal container with a tight-fitting lid (such as an empty coffee can or biscuit tin) is a great choice, because the metal will be naturally light-tight; the lid can be sealed with black tape, and it's rugged enough to be used over and over again. Simply drill a ¼in. (8mm) hole in the side of your container and glue a homemade pinhole panel into place, taping around the edges to avoid any light leaks and using a piece of card with a tape 'hinge' as a shutter. Load your camera with a sheet of photographic paper (or film if you're feeling adventurous) and you're ready to start your pinhole adventure.

The process of making your own pinhole lens takes a matter of minutes. The steps on the opposite page show how it's done.

You will need:

empty aluminium drinks can; scissors; eraser; ballpoint pen; fine sandpaper; needle or pin

1 Cut a small square of aluminium (roughly 1in./2.5cm sq.) from an empty drinks can. This will be your pinhole lens panel.

2 Place your lens panel on top of an eraser and make a shallow indent roughly in the centre of the aluminium with a ballpoint pen.

3 Flip the lens panel over so there's a raised bump in the middle. Lightly sand the protuberance to thin the aluminium; if you sand it too heavily and make a hole, head back to step 1.

4 Turn the lens panel over again, so it is sanded-side down, and use the narrowest pin or needle you can find to make a tiny hole in the thinned metal at the centre. Use a 'drilling' action and gentle pressure rather than trying to force it through: you don't need to push the pin/needle all the way through, you just need to make a super-small opening.

5 Hold your panel up to the light and check out your hole: you've just made yourself a pinhole lens!

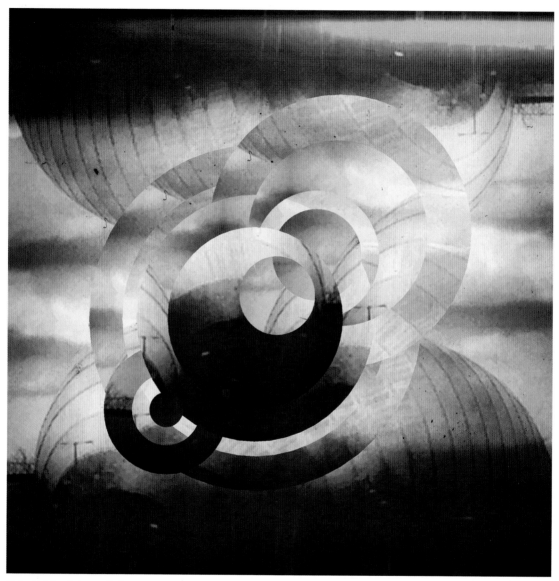

Claire Quigley, *Spheres of Influence*

Appy mistakes
Use apps to emulate light leaks

● ○ ○

Light leaks used to be the bane of analogue photography: no one wanted to have a photograph ruined because light had crept in through the back of the camera and exposed their film. Light leaks were mainly caused by failed light seals (or 'light traps') around the hinged doors that you'd open to load your film. Over time the foam seals would get damaged or simply 'rot' and crumble, allowing tiny chinks of light to get through to the film.

The only way of knowing light was leaking was when you got a film processed and could see that light had leaked across it, at which point it was too late to do anything about it. Light leaks weren't always bad, though. They might have been unpredictable, uncontrollable, and generally unwanted, but sometimes a dramatic flash of orange-yellow across the edge of a picture could add a certain 'je ne sais quoi' atmosphere to an image.

Digital cameras don't have hinged backs that open to let you load them, so there's no risk of light leaks any more. However, you can still recreate the look of these 'happy accidents', as Claire Quigley has done with this picture of the IMAX at Glasgow Science Centre. The original photo was taken on an iPhone using the Hipstamatic app's 'double exposure' feature. Claire then used the Snapseed app's 'Retrolux' setting to add the intense light leak at the top of the frame, before running the image through the Fragment app to create the interlocking circle effect.

You will need:

app-compatible phone, Hipstamatic app, Snapseed app, Fragment app

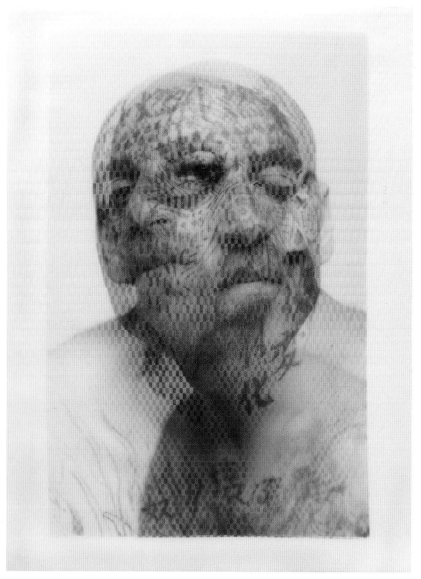

David Samuel Stern, *Doug*

Cut and weave

Make woven portraits from your photos

● ● ●

It would seem counterintuitive for a photographer to cut up their images, but this is exactly what David Samuel Stern does. He begins by photographing a model in a studio, against a seamless backdrop and with a fairly simple lighting set-up, revealing a variety of poses and expressions, from different angles. After the shoot, David goes through the resulting files and makes dozens of Photoshop mock-ups of various combinations of pairs of the images that he thinks will overlay in an interesting way. He then picks the combination that stands out and prints the two files onto archival vellum, often making prints that are upwards of 3ft (1m) long.

Once he has his two large-format prints, one is cut into vertical strips and the other is cut into horizontal strips. The cutting is time-consuming, as everything has to be taped down, carefully measured and marked, and cut along a straight edge with an extremely sharp blade. David then meticulously weaves the strips together to create his unique vision.

You will need:

two images, metal ruler, cutting mat, craft knife

Do it your way
Prints made on paper or canvas – including regular photo prints – are perhaps a more accessible starting point for your experiments than vellum. You could even try printing on transparent film and weaving that to create a multi-layered look.

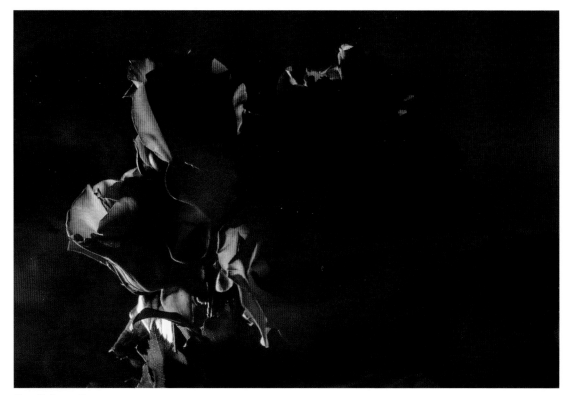

Elena Kulikova, *Bloom*

In a spin

Create motion blur using a turntable

● ● ○

Elena Kulikova takes a novel approach to achieving motion within a relatively controlled environment, by photographing her subjects on top of a record turntable. With her subject in position, Elena sets a long exposure on her camera and positions a wireless flash with a coloured gel over it in the background. Then, while the turntable rotates, she takes her shot. The long exposure records the subject's movement as a blur as it spins, but the pop of flash is enough to create a recognizable, sharply frozen image within the kaleidoscopic colours.

Adjusting the turntable speed and the exposure time allows Elena to create longer and shorter streaks of blurred movement, until she is happy with the outcome, while the gel on the flash can be changed to alter the colours. As a result, all the effects are done in-camera, giving everyday objects a new twist.

You will need:

camera, wireless flash, coloured gels, record turntable, flowers (or other subject)

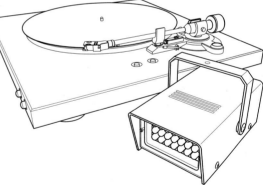

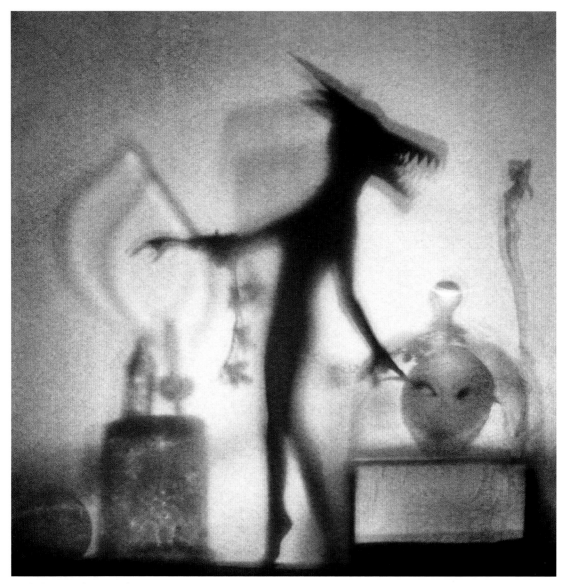

Heidi Clapp-Temple, *Not Today*

In the shadows

Create a miniature shadow theatre

● ○ ○

Creating a miniature 'shadow puppet stage' is an incredibly effective way of producing visual narratives from very simple materials. Entwining truth and fiction, Heidi Clapp-Temple fabricates her tabletop sets out of paper, found objects, drawings and photographs, and yet these simple materials produce images that are sophisticated, otherworldly and utterly intriguing.

The 'magic' lies in the piece of semi-translucent paper that is hung in front of the sets, immediately simplifying the scene and transforming the disparate collection of items into a cohesive narrative. Heidi carefully positions multiple lights behind the set, fine-tuning the shadows and composition to create a fantastic narrative, before photographing it.

You will need:

camera, tripod, semi-translucent paper, light, scrap paper, source images, pens and pencils, scissors, trinkets and knick-knacks

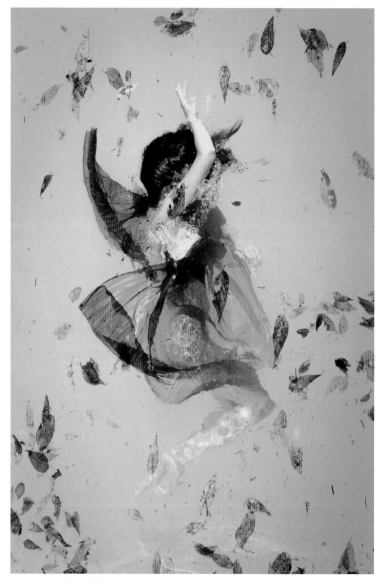

Kat Moser, *Edenic Flight*

A many-layered thing

A contemporary take on 19th-century collage

● ● ○

Photomontage – a collage made from photographs – has a long and varied history dating back to the mid-1800s. Although the original technique of manually cutting, ripping, tearing, and then layering and gluing various photographic images can now be done wholly using image-editing software, some artists, such as Kat Moser, still embrace an analogue approach.

Kat's photomontage series *Enfleurage* takes its name from the 19th-century process of creating perfume by pressing flower petals between two glass plates coated with odourless oil to create an exquisite fragrance. 'I like the idea that this process can act as a metaphor for my own process of layering many separate images to form a new visual experience,' says Kat, who begins by photographing various subjects, from reflections in water and textures of stone architecture, to the female form. She prints grids of her source photographs on transparent film, and then cuts each element out and engages in the experimental and intuitive process of physically 'building' her layered images on a light table and re-photographing the final composite.

You will need:

source photographs, printer, transparency film, cutting mat, scalpel, light table or light box, camera

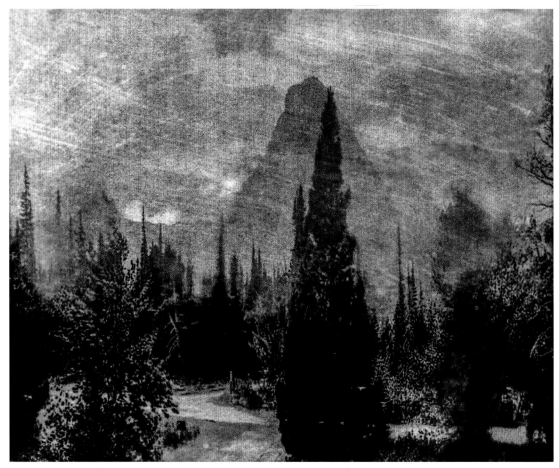

Marcus DeSieno, *48.2946856, -113.2414781*

Salt-paper print

Combine an old process with modern techniques

● ● ●

In his *Surveillance Landscapes* series, Marcus DeSieno takes stills from surveillance camera feeds that are freely accessible online and transforms them using a salt-paper negative process that is very similar to the technique invented by William Henry Fox Talbot. To try Marcus's method yourself, follow these steps:

1. Coat a piece of 5×4in. paper with both salt water and a silver-nitrate solution to create light-sensitive salt paper (there are plenty of instructions online on how to do this). Then access a video feed on your computer and photograph the on-screen image – Marcus uses a large-format (5×4) camera.

2. Develop the salt-paper negative and allow to dry. Add a layer of wax to the negative to increase the paper's transparency, a traditional method used to aid contact printing, which has the added benefit of giving the automated digital image an individual touch.

3. In the darkroom, contact-print the paper negative onto regular silver gelatin photo paper to create a same-size positive print. Then scan this positive image, not only to increase the image size, ready for printing, but to emphasize the brush marks made during the coating and waxing processes, enhancing the 'hand-made' nature of the image.

You will need:

darkroom; sensitized salt paper; large-format camera; sodium thiosulphate (for fixing the salt print); wax; photographic paper for contact printing; scanner (or digital camera)

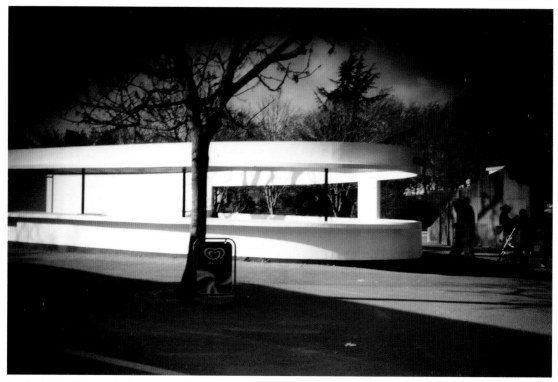

Ben Cottingham, *Penguin Pool*

Box Brownie magic

Discover the past with a vintage camera

● ○ ○

Jumble sales and second-hand shops (and, of course, eBay) are great places to find old, discarded cameras, which can produce idiosyncratic images. That's exactly what photographer and vintage camera fan Ben Cottingham does. 'I've always loved the design of the Penguin Pool at London Zoo,' he says, 'and it just felt "right" to try and capture its form on a vintage camera. I was playing around with an old Kodak Box Brownie at the time and this seemed like an appropriate choice.'

One of the major joys of film is that you never know how an image is going to turn out until the film is developed. By working film into your photographic practice you can not only revisit the romance of yesteryear, but also experience the magic of the 'reveal'.

You will need:

vintage camera, film

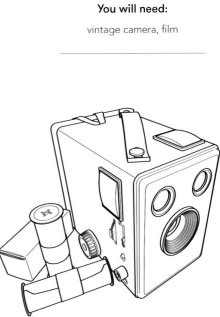

Do it your way

One of the biggest challenges with using old cameras is sourcing film, with some formats being almost impossible to find in good condition. For this image, Ben respooled 120 roll film onto the 620 format spools that fitted his Kodak Brownie camera. This is quite a common 'hack' and a great way of bringing an otherwise obsolete camera back to life.

Black-and-white film processing

Black and white is a great place to start with shooting film, not least because it's easy to process it yourself at home. As well as saving money, it means that as you gain experience you can start to influence the appearance of your negatives, and therefore your photographs. Processing a film requires a few specialist items, but if you look online for used equipment you should be able to cut the cost.

Loading your film onto the 'spiral' that holds it in the developing tank is the first – and perhaps hardest – part of processing a film, mainly because it needs to be done in total darkness. The trick is to practise in the light with a scrap film first, so you familiarize yourself with the process. Trim the leader from your film and then locate the end of the film under the two guides on the spiral. Gently pull the end of the film halfway around the spiral and then turn one side of the spiral while holding the other to wind the film on.

Once your film is in the light-tight developing tank and the lid is secure, you're ready to step back into the light and process your film. The success – or otherwise – of this comes down to a number of factors, but the flowchart opposite will guide you through the process.

You will need:

film developing tank; darkroom or changing bag for loading the tank; developer, stop bath, fixer; measuring jugs and cylinders/ graduates; thermometer; timer; bottle opener; scissors; clothes pegs

Your developing tank should tell you the minimum amount of chemistry you need per film (the figure is often stamped on the base of the tank). Don't be tempted to use less as your film might not be fully covered by the chemicals and will only be partially developed. Pay particular attention to the dilution ratio of your developer, stop and fixer chemicals, and try to mix your chemicals as accurately as possible.

→

Most developers (and other chemicals) are optimized to work best at 20°C (68°F). The development time will depend on the developer and film you're using; different combinations require different processing times, so check the timings given by the respective manufacturers. The temperature can also affect the processing time. Timings for stop bath and fixer are the same for any film.

↓

The order of the chemicals is developer, stop bath, fixer. With each chemical, start the timer as you pour it into the developing tank and begin to empty the tank a couple of seconds before the time is up. As soon as the developer has been poured out, pour in the stop bath (or water); as soon as the stop time is up, drain the tank and pour in the fixer.

↙

At each stage of the process you need to agitate your developing tank to ensure your film is covered by 'fresh' chemistry. Don't shake the tank vigorously, just invert it a couple of times. Agitation usually involves inverting the tank two or three times every minute and should be done consistently; after you've agitated it, give the tank a light tap on a surface to dislodge any air bubbles.

↘

When your film is washed you can remove it from the spiral and hang it up to dry. A drop or two of 'wetting agent' can help prevent drying marks, but a couple of drops of regular washing-up liquid in the final wash water as you remove the spiral does a similar job. Try and hang your film in as dust-free an environment as possible, so it doesn't end up with a coating of dust as it dries. Your dry, processed film can be cut into strips and slid into negative filing sheets for protection.

←

Once you have fixed your film, you need to wash it by placing the developing tank under a running tap for 10-15 minutes (with the water at roughly 20°C/68°F). Alternatively, fill it with water, agitate for a few minutes, and then empty and replace the water.

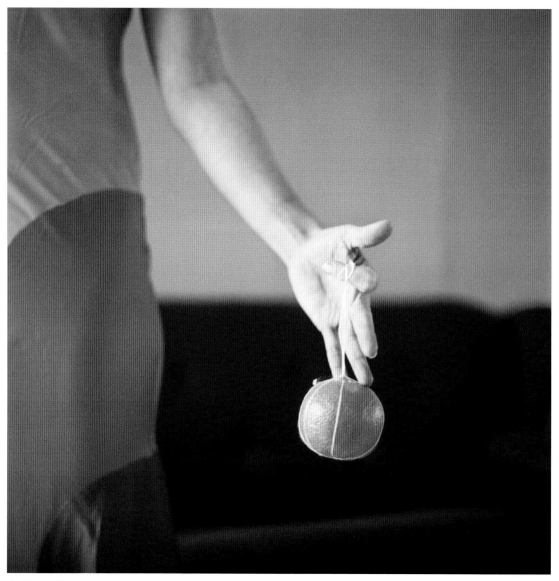

Cig Harvey, *Orange*

Mind mapping
Use free association to inspire your ideas

● ○ ○

If you ever feel stuck in a creative rut, try free association to get the artistic juices flowing once more. Set aside about half an hour every day to sit down with a pen and paper and write whatever comes to mind. Do this quickly to keep self-conscious thoughts at bay. Remember, no one needs to see what you have written, so be as true to your thoughts as possible. Nine times out of ten what you jot down will be gibberish, but there will also be the odd gem of an idea to pursue. Distill your ideas down to just a single idea or one word – try to be as specific as possible – and begin a mind map.

Fine art photographer Cig Harvey is a great advocate of free association and uses this process regularly to inspire her work. 'My pictures come from a place of curiosity. I write the central idea or word on a large sheet of paper or on the wall and begin a free association. I write down everything that comes to mind: metaphors, symbols, verbs, nouns, gestures, weather, animals, landscapes, emotions, light, depth of field, palette, frame, format, motion.' This daily routine of putting her mind to paper, and the rabbit-hole process of mapping and exploring her ideas, expands Cig's awareness of the visual cues around her. Think of the mind map as a list of ingredients from which you can construct a photograph. You may tap into a whole new vein of creativity.

You will need:

pen and paper to explore
your ideas; camera
to record them

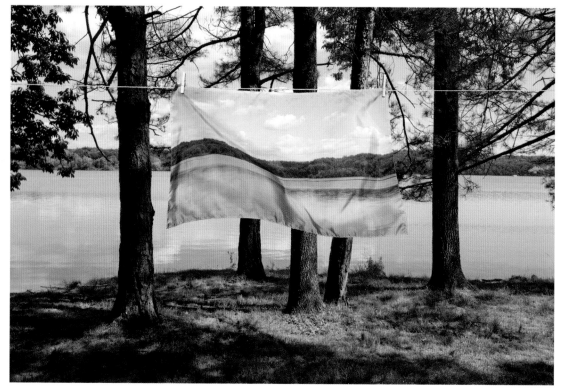

Keith Sharp, *Suspended*

Double take

Print your image onto fabric

● ● ○

For his series *Fabrications*, American artist Keith Sharp incorporates prints made on fabric into landscape and interior photographs to create images that question the truth of what we see. After sketching out his ideas, Keith headed out on location to photograph his source material, printing some of the natural scenes onto silk.

In the image shown here, two views of the same location were taken: one from in front of the trees, so they didn't appear in the shot, and one from behind. A silk print was made of the treeless image and this was hung on a washing line and photographed outdoors, before being seamlessly integrated into the second view using Photoshop.

You will need:

camera, tripod,
printed image

Do it your way

Making large-format prints on silk is expensive, but don't let that stop you from giving it a go. Instead of silk, get prints made on vinyl (like the banners used at trade shows) or canvas, or even on large sheets of paper. You can also photograph smaller details, rather than sweeping vistas, so you don't need such sizeable prints.

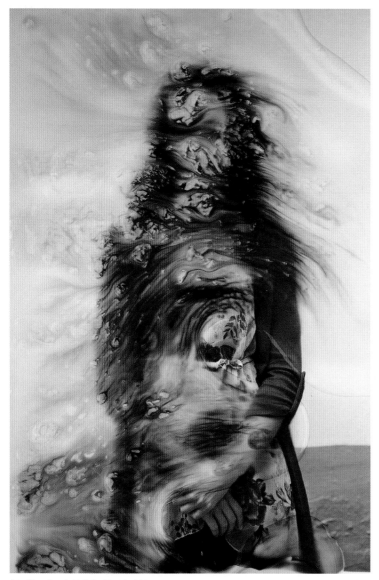

Angélica García Pulido, *Untitled 13*

Face off

Erase elements of a photograph using analogue methods

● ● ○

There are many different ways to distort an image on a computer using software, but what about manipulating an image after it has been printed? This is exactly what Angélica García Pulido decided to explore in her series of works *Vacío (Emptiness)*.

The images were captured using a digital camera and Angélica printed them out so she could manipulate the surface of the print by hand instead of using any in-computer techniques. While experimenting with different liquids to work the images with, she accidentally threw nail polish remover onto the prints and was instantly captivated by the way in which the ink dissolved and the 'person' disappeared. Angélica carefully monitored the erosion caused by the acetone and photographed each print at the precise moment that she felt the sitter's 'disappearance' was at the right stage.

You will need:

inkjet print, acetone, protective clothing (face mask, goggles and gloves)

Caution

This is something you can do easily at home, but always work in a well-ventilated space (ideally outdoors). You should also wear appropriate protective clothing (a face mask, goggles and gloves).

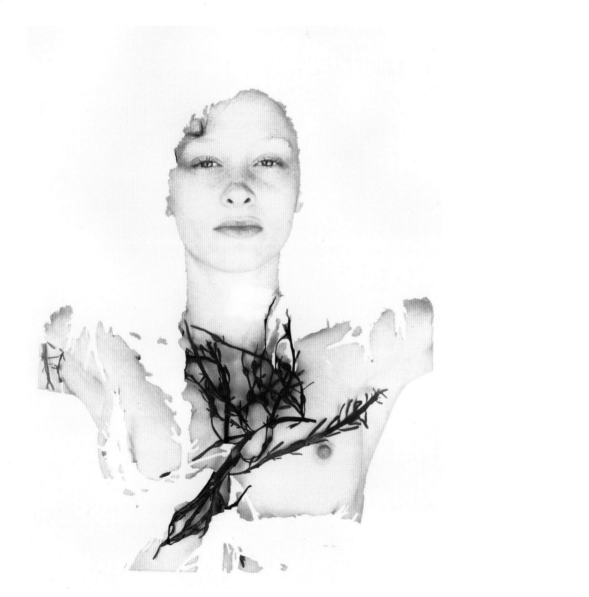

Elizabeth Opalenik, *Kaitlyn*

Carbon printing
Create the illusion of three dimensions

● ● ○

Carbon printing emerged in the 19th century as an alternative to early types of silver-based black-and white prints, which were seen to be highly susceptible to fading within a short space of time. In contrast, the carbon process was found to produce high-quality prints that were fairly impervious to fading.

The distinctive quality of a carbon print is that it is possible to create a bas-relief, giving a textured, almost three-dimensional finish. The process involves creating a carbon tissue – usually a paper support coated with a layer of gelatin combined with a pigment – which is bathed in sensitizing solution and then dried. The next step is to expose the carbon tissue to ultraviolet light through a photographic negative, which will harden the gelatin depending on how much light reaches it. The tissue is then developed in hot water, which in turn dissolves any unhardened gelatin. You are left with a pigment image that can be transferred onto a wide variety of surfaces, such as paper, metal, glass or various synthetic materials.

Today this technique is pursued by a new wave of enthusiasts, such as photographic artist Elizabeth Opalenik, who enjoys the process of distressing her finished images so that they do not look quite so pristine. Here, Elizabeth has removed gelatin from the image using sculpting tools to alter the edges.

You will need:

carbon tissue made from paper, gelatin and pigment of choice; sensitizing solution; photographic negative; hot water (105–115°C/220–240°F); surface onto which the carbon print can be transferred

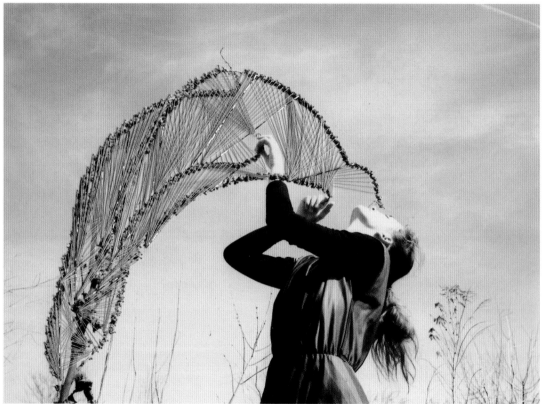

María Aparicio Puentes, from the series *Be Brilliant*

Sew over you

Take a needle and thread to your old photos

● ● ○

Take one of your own photographs, or select a found image such as a vintage postcard, and transform it through clever embroidery and stitching – the results can be incredible, as you can see with this work from Chilean artist and architect María Aparicio Puentes.

María works with different photographers, whose work she sees as appropriate to a particular project. In this series, *Be Brilliant*, María invited photographers Lukasz Wierzbowski and Ksenija Joviševic to create photographs that she could embellish. Working closely with the structure of the photographs, María created geometric shapes using a needle and an array of coloured threads, emphasizing pre-existing spatial relationships between the subject and the space around them.

Although the concept may seem simple, the execution is beautiful and the results certainly add to – and often elevate – the original photographs. The stitched images become magical, fantastical, multicoloured creations imbued with new meaning, and it is interesting to see the juxtaposition of a fairly instantaneous art form (photography) combined with the slow and contemplative art of embroidery.

You will need:

an existing photograph
(or other printed image),
an embroidery needle and
coloured embroidery thread

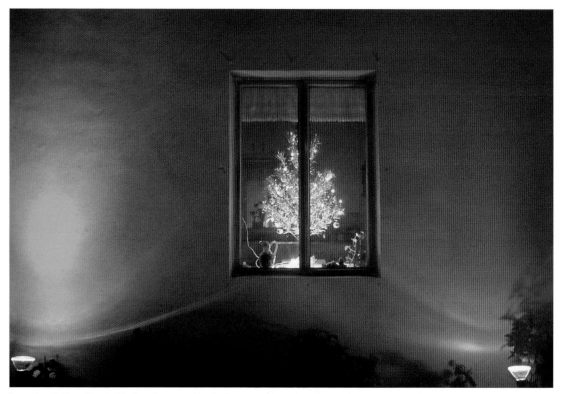

Patty Carroll, *Xmas Tree in Window, Pompano Beach, FL*

Night shoot

Create saturated imagery using artificial lighting

● ○ ○

Places that might seem mundane during the day can come alive at night, as artificial lighting creates intense, saturated colours that we don't appreciate fully with the naked eye. A weak hint of colour will appear much stronger and more obvious when it is photographed over an extended period of time.

You can shoot long exposures at night either digitally or on film, but different rules apply. With a digital camera you will need to deal with long-exposure noise in your editing program and should also set the camera's white balance to its daylight setting to ensure the colours don't wash out.

Shooting on film – especially transparency film – guarantees your nocturnal colours will pop, like in this image from Patty Carroll's *Sunset after Dark* series, which has a timeless quality, despite being taken in the late 1970s. 'I used 35mm transparency film and long exposures, on a tripod, no extra lights, no manipulation. This approach allowed the colour to become more saturated with the amount of time for the exposure.'

When using film, you will need to be aware of reciprocity failure. When light levels drop really low and exposure times exceed around 1 second, film becomes progressively less responsive and needs 'extra' exposure. How much extra is needed varies from film to film, so check the manufacturer's details for the precise recommendations.

You will need:

camera, tripod

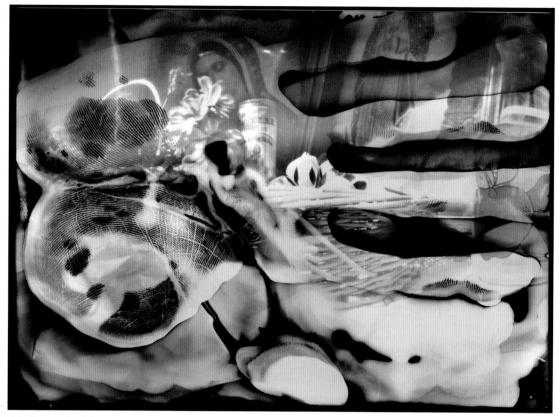

Chris Keeney, *Guadalupe a Mano*

Double vision

Combine photographs and photograms for a new look

● ● ●

Finding himself with a large stack of paper pinhole negatives that needed to be developed and fixed, Chris Keeney had an idea that would make him take a leap of faith and sacrifice one of his negatives to experiment on. 'I asked myself what would happen if I were to dip the palm of my hand into the tray of liquid photographic developer and then press it directly on top of the undeveloped paper negative? Would I see my palm and fingerprints merged into the photograph? Or would I have to take it a step further and flip the light switch for half a second to make a darkroom photogram?'

The combination of the two techniques led to some interesting results and Chris has been experimenting ever since. To try it yourself, follow these steps:

1. Start by exposing a piece of photographic paper under an enlarger in the darkroom, as if you are making a regular print from a (film) negative.

2. Put the exposed photographic paper into the developer. While the latent image is emerging, dip your hand into the developer and place it directly on to the print, then expose it very briefly to white light to create a photogram (Chris switches the overhead light on for around half a second).

3. Remove your hand (or stencil) and allow the print to carry on developing, then fix it and wash it. Wash your hand thoroughly after placing it in the chemicals.

You will need:

exposed (but unprocessed) paper negative or photographic print, darkroom, stencils (optional)

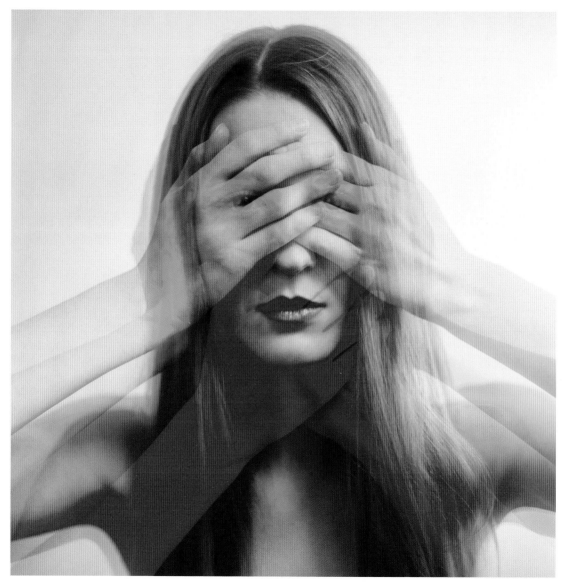

Mathieu Stern, *The Three Wise Monkeys (Trichromy)*

Trichromy

Make pop art using an early photography technique

● ● ○

Trichromy dates as far back as 1855 and the work of Scottish physicist James Clerk Maxwell, and forms the basis of colour photography. Maxwell's research was based on the theory that the human eye sees colour because of three cone types in the retina, which are sensitive to red, green and blue wavelengths.

Maxwell suggested that taking photographs of a subject using filters in each of those colours, and then projecting the images through matching filters (and overlapping them), would create a 'full colour' image. This was put into practice in the early 1900s, but it wasn't until Kodak introduced its first 'tripack' film – Kodachrome – in 1935 that colour photography was truly revolutionized.

French photographer and filmmaker Mathieu Stern is an ardent fan of filters and vintage lenses, and has a passion for photographic experimentation. Here he has taken this seemingly antiquated analogue technique and approached it using modern digital technology. You can find out how to start experimenting for yourself on the following pages.

Trichromy

1 Plenty of inexpensive black-and-white filter sets that include plain red, green and blue filters can be found online, but if you want to get really technical, look for tricolour filters with the following Wratten numbers: 25 (red), 58 (green), 47B (blue).

2 Once you've got your filters, photograph your subject three times on black-and-white film. Each exposure should be made through one of the filters, so you end up with three negatives: one red-filtered, one green-filtered and one blue-filtered. It is important that you make a note of the order in which you use the filters ('RGB' is the most memorable).

You will need:

film camera loaded with
b&w film; red, green
and blue filters; editing
software with channel
control; tripod (optional)

3 Once your film has been processed, scan the
three frames and give them obvious filenames
(e.g. 'red', 'green' and 'blue'). Open these images
in Photoshop (or similar) and create a new, blank
image at the same size and resolution as your scans.

Starting with the red-filtered photograph, select
the whole image, and copy and paste it into the
red channel in your blank image. Repeat the
process with the green-filtered and blue-filtered
photographs, copying them to the green and
blue channels respectively in the blank image.

When you view all three channels together you
should see a full-colour image.

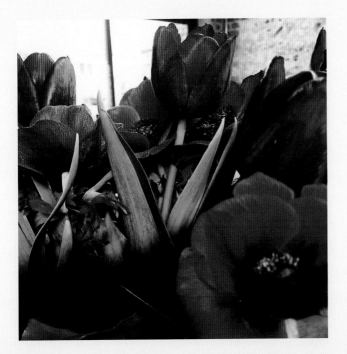

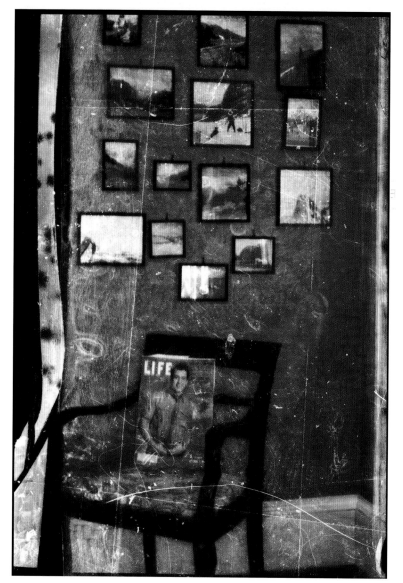

Smith Eliot, *Life*

Scratched!

Get creative with your old negatives

● ● ○

Visual artist and analogue photographer Smith Eliot adopts a different take on collage, drawing on a vast collection of old large-format negatives, some of which she has bought in bulk from garage sales, and others that are her own. Each negative is modified through cutting, scratching, marking and inking, with more unconventional materials such as blood, salt, hair, fur and silver shavings introduced to the film as well. The resulting pieces are laboriously assembled on a light table, and are mostly held together using sticky tape. Once the final image has been composed, Smith scans the composite to create a digital negative she can print from.

You can try this technique for yourself by bringing together a disparate collection of negatives and experimenting with adding pen marks or paint, scratching into the film and cutting sections away, and isolating different elements. You can then set about 'reconstructing' your image on a light table, using sticky tape to hold your assemblage together.

You will need:

negatives, light table, pens, paint, ink, scissors, scalpel, sticky tape

Harold Davis, *Schizanthus grahamii and Iceberg Roses*

Let there be light

Create botanical art using a light box

● ● ○

At the core of Harold Davis's technique is a simple light box, a continuous light with a diffused white cover that was once commonplace in any photographer's studio for viewing transparencies. Here, however, Harold uses the light box as his light source, on to which he arranges his floral subjects.

With his camera mounted on a tripod, the photographer will then shoot multiple high-key exposures covering a range of maybe six or seven stops. The resulting images are then combined in Photoshop, placing the longest (lightest) exposure at the bottom of the layer stack and then effectively 'painting in' darker elements. The result creates the impression of a translucent subject, as the brighter exposures reveal elements concealed by those that are slightly darker, but the overall shapes and forms of the objects are maintained. In this instance, the image was finished by placing it in Photoshop on a straight white background.

You will need:

camera, tripod, light box, flowers, editing program with layers

Damion Berger, *Homage to Lartigue (after Kertesz), Sardinia 2005*

Distortion and light
Take a photograph from under the water

● ○ ○

In his series *In the Deep End*, Damion Berger smuggled
an underwater camera into public swimming pools
where photography is generally prohibited. Like a
candid street photographer he worked for the most
part without the knowledge or complicity of his
subjects, often holding his breath until near bursting
point as he swam into position and tried to hide his
camera until the 'decisive moment' presented itself.

Damion decided to photograph in black and white,
as without the immediacy of colour and the blue hue
of the water to provide context, it is not immediately
obvious that these shots were taken underwater.
This underscores the abstract sense of suspension,
movement, distortion and reality that permeates
through the series.

You will need:

underwater camera (or
underwater camera housing
for your DSLR/CSC)

Do it your way

*While high-end underwater cameras can be
expensive, there are plenty of second-hand
'compact' film and digital cameras that can be used
underwater with 'point-and-shoot' simplicity. They
may not be as sophisticated as professional models,
but they'll get you shooting under the surface with
minimal fuss and are far less conspicuous.*

Robert Pereira Hind, *Pratum Meadow II*

Gold leaf and transfers

Make decorative pieces with this traditional technique

• • •

Image transfers allow you to take an image printed on one material and transfer it to another. In his series *Out of Eden*, fine art photographer Robert Pereira Hind has taken the process to the next level by combining his image transfers with gold leaf.

1. Select a backing board, such as wood or metal, and cut it to size before painting and sanding it, and filling any gaps. Once it's prepared, apply gold leaf sheets very carefully using glue and then coat them with shellac varnish.

2. The next step is to transfer a laser-printed photographic image onto your gold leaf. Start by covering the area on the gold leaf background where your image will be placed with the acrylic resin. Then place your laser-printed image face down on the acrylic resin. Use a ruler to smooth out any air bubbles that might have appeared, and leave to dry.

3. Once the resin is dry, use water and a soft cloth to slowly rub the paper away. You should be left with a transferred image that can be 'fixed' using spray glue and then give it several coats of glaze to protect it.

You will need:

laser-printed image; gold leaf schlag metal sheets; acrylic resin; PVA glue; organic pigment; shellac; oil glaze; spray glue; board or piece of wood

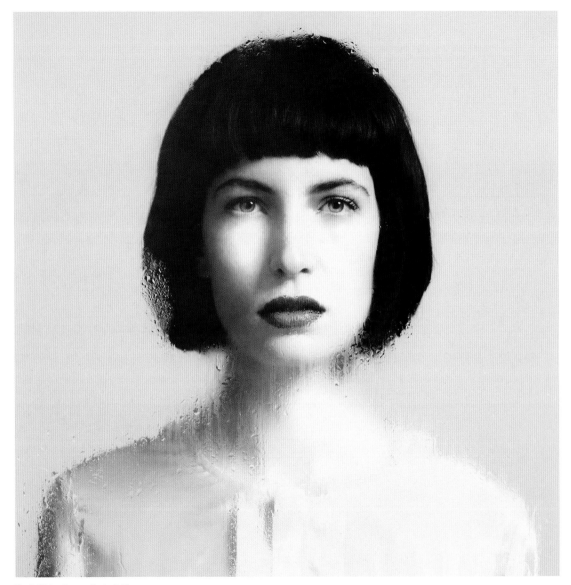

David Ryle, *Steam Portrait One*

Hot stuff

A special effect using steam

● ○ ○

This image was shot by David Ryle in his studio, using models selected from a casting. The lighting on the subject was relatively simple: it consists of one large key light positioned at a 45-degree angle to the subject, with white polyboards acting as fill light. Two separate lights were then used to light the background. You could emulate this using a variety of light sources and reflectors, even using a large window as your key light.

David wanted to build up layers of diffusion between the model and the camera, so he positioned a number of sheets of glass between the two. He then sprayed the glass with a water and glycerin solution and used a haze machine (a type of fog machine) to create a smoky atmosphere in the studio. It was then a case of shooting through the haze and the glass to create the alternative portrait.

You will need:

camera, lighting, glass/clear acrylic sheets, water, glycerin (optional), smoke (optional)

Do it your way

Experiment with your own 'steam shots' using clear acrylic (often used in large picture frames) instead of glass, or using a single sheet instead of multiple layers. To create the steamy effect, you might consider boiling a kettle instead of using a hazer, but make sure you don't scald your model! Alternatively, theatrical suppliers often sell aerosol cans of fog that can be used to 'smoke' a room.

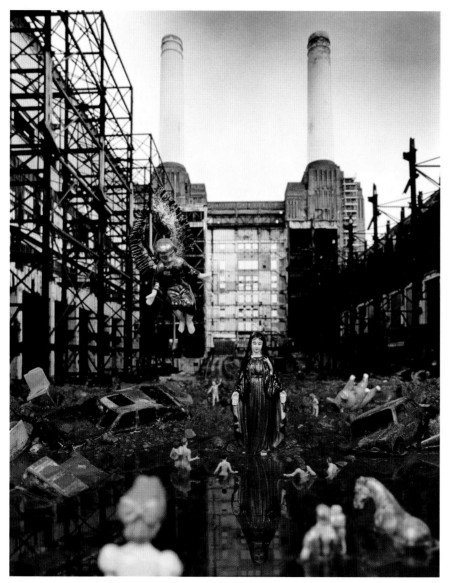

Etienne Clément, *La Vierge de Miséricorde*

Create a scene

Make your own scene and shoot it

● ○ ○

Ever wanted to revisit your childhood and rediscover the wonderment and sense of play that goes hand in hand with being a child? French photographer and mixed-media artist Etienne Clément does just that on a daily basis.

Setting the scene is the most time-consuming part of the process, and Etienne can spend up to five months creating a model and staging a story; the actual photography can take as little as a day to finalize. Etienne's background is in architectural photography, particularly what he refers to as 'ruined architecture'. He spent many years photographing derelict landmarks, but wanted to inject some soul and narrative back into these spaces. Ever the magpie, Etienne started to collect the detritus left behind in these ruined spaces by human beings. Much of this was toys. To these Etienne would add figurines acquired from online auction sites. With these elements and his architectural photographs he then began to create his fantastical and magical scenes, often adding a whole host of incongruous materials such as mud and talcum powder.

Etienne refers to his work as 'microscenography photography' and finds inspiration in all sorts of places: paintings, pop culture, a personal experience, or a memorable event.

You will need:

camera, tripod, tabletop, images of buildings or other locations, toy figures, cars and other elements, mud, talcum powder or any other medium necessary for the scene

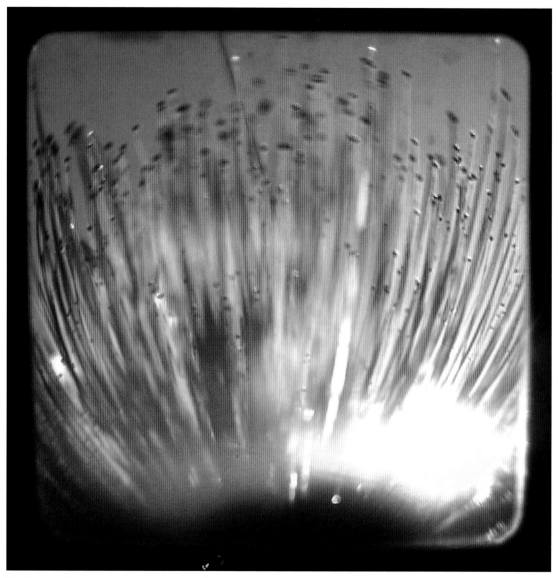

Chris Keeney, *Bliss*

Faking analogue
Through the Viewfinder (TTV) photography

● ○ ○

TTV or Through the Viewfinder photography is when you use one camera (usually a digital camera) to photograph through the viewfinder of an old, twin-lens medium-format camera. In doing this, you are not only recording the image that appears on the focusing screen, but you will also pick up the dust, scratches, uneven edges and softly focused (and slightly darkened) corners that typify these old cameras, imbuing your photograph with an authentic vintage patina.

Chris Keeney's favourite old film camera to use for this is the Kodak Duaflex I, although there are plenty of similar models to be found in second-hand shops, flea markets, jumble sales and online. 'If you take your time and shop around you can get them for close to nothing,' says Chris. 'Also bear in mind that you're not going to use the functioning part of the camera, so it's not important that the camera actually works. Each camera creates its own unique effects, so I usually buy a few of them at a time to see which one has the best viewfinder.'

Details on how you can take your own TTV photographs appear on the following pages.

TTV (Through the Viewfinder)

Shooting TTV images is guaranteed to give your digital snaps a genuine vintage vibe, as you shoot through the patina of an old-school film camera's viewing screen. The great thing is that you don't need to spend a lot to get stunning images: you can take your digital shots using a compact camera or smartphone (both are preferable to a larger DSLR or CSC) and the camera you shoot through doesn't need to be a top of the line model from back in the day.

In fact, when it comes to the vintage camera you choose, the gnarlier the better, as the more dust, dirt and scratches on its screen, the more character your shots will have. Don't forget either, that you are only going to be using the viewing screen and lens, so a camera with a broken shutter or even something that takes a long-forgotten film format will work – and may be even cheaper as a result.

An equally important component is the 'contraption'. This is the not-so-technical name for the tube (usually made of card) that creates a light-tight tunnel between your two cameras, ensuring that the viewing screen on your old film box is positively glowing. This spread shows you how to bring it all together.

You will need:

digital camera or smartphone; medium-format film camera with waist-level viewfinder; heavy card stock; scissors/craft knife; gaffer tape

This is a basic template for a contraption that can be made from a single sheet of card stock. The dimensions should be based on the digital/film camera combo you are using.

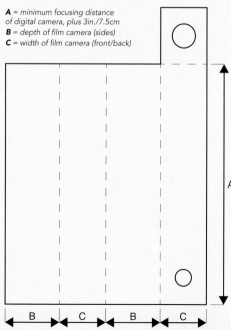

A = minimum focusing distance of digital camera, plus 3in./7.5cm
B = depth of film camera (sides)
C = width of film camera (front/back)

Make a lid at the top with a hole for your digital camera/smartphone lens to point through. This will help stop any light 'leaking' into the contraption.

The contraption is nothing more than a long card box. Its width and depth should be a fraction larger than the width and depth of your film camera, so the film camera can slide snugly inside.

The length of the contraption is critical. This must be at least the minimum focus distance of your digital camera, plus a little extra, just to be sure. Any shorter and your camera won't be able to focus on the viewing screen.

Assemble your contraption using gaffer tape: it will not only hold it all together, but also help to prevent light leaks.

Slide your film camera into the bottom of the contraption and use gaffer tape to hold the two together.

Cut a hole at the front/bottom of the contraption for the film camera's viewing lens to poke through.

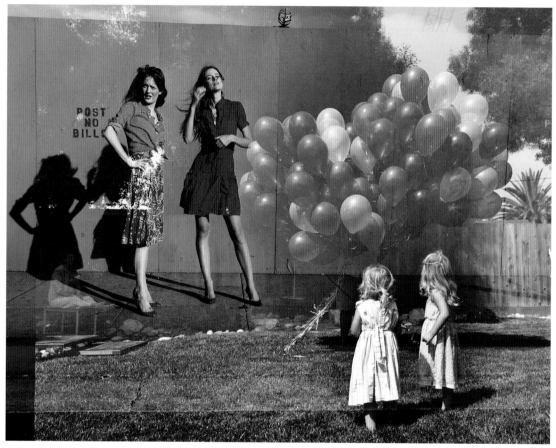

Tierney Gearon, from the series *Explosure*

Seeing double

Create double exposures in-camera

● ○ ○

Discovered by Charles Saatchi in 2001, Tierney Gearon was propelled into the limelight when her work was featured in an exhibition at the Saatchi Gallery in London. Tierney became an overnight sensation when images of her children came under public scrutiny. Since this rather controversial debut, she has been pushing the envelope of contemporary photography on a regular basis.

Tierney's series *Explosure* uses images that have been created by exposing film twice inside a camera – 'no Photoshop, no retouching, no nothing!' Tierney simply shoots a roll of film and then reloads it in her camera and shoots something else on top of it. There is no way of telling what images will be combined, resulting in the creation of 'chance narratives' that intrigue and delight in equal measure.

Tierney became so enamoured with the 'surprises and accidents' of the process that she has continued working in this way for more than two years, photographing scenes with friends, family and bystanders. 'Two boring images suddenly become more interesting than a regular photograph,' she says. So why not invest in a film camera and try out in-camera double exposures for yourself?

You will need:

film camera, film

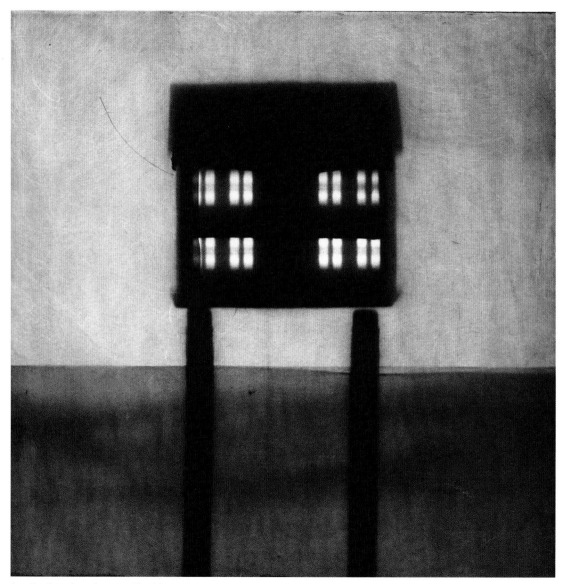

Jennifer Shaw, from the series *Flood State*

Small-scale photogravure

Discover a process from the dawn of photography

● ● ●

Using relatively commonplace materials, including sushi grass, plastic nets, grocery bags and small children's toys, Jennifer Shaw's *Flood State* is a series of powerful images made as a direct emotional response to the two major floods that occurred in Louisiana in 2016.

Rather than photograph her constructs, Jennifer created her layered compositions on top of light-sensitive polymer photogravure plates, a modern and less toxic method of creating photogravures – an intaglio printmaking process dating back to the very dawn of photography. The plates were exposed to UV light and developed by gently scrubbing them under running water, which produced an 'etched' plate with thousands of indentations of varying depths. After drying and curing, the plates were inked and printed on an etching press.

You will need:

photogravure plates; darkroom; objects to create the scene; UV light; ink and etching press; paper to print onto

Do it your way

The cost of having photogravure plates made can be high. However, the basic premise is similar to making a photogram, so why not try arranging items on a piece of photographic paper and exposing it to light?

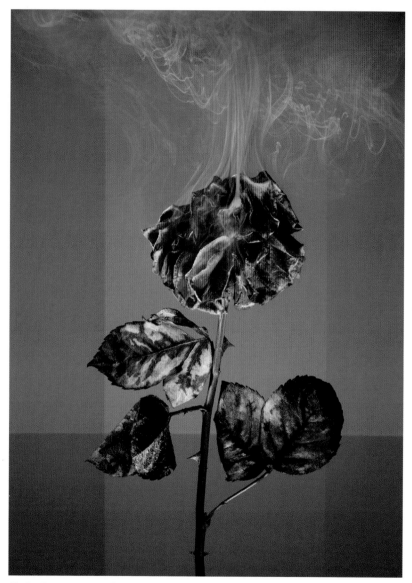

Charles Emerson, *A Rose from Auschwitz*

Dying rose
Submerge flowers in water and ink

● ● ●

Artist Charles Emerson looked to the Dutch masters as inspiration for his bold and breathtaking series *Blacklight*, in particular the vanitas tradition in which artworks were steeped in symbolism. Charles created his own symbolic images in which he explores ideas of fragility in life, death and the hereafter.

Charles constructed a set using a fish tank, water, glass plates, mirrors, flash and UV lights. The flowers were submerged in the tank as the core of each piece; he then introduced inks, dyes and paints via a syringe to imbue the scene with a sense of movement and life. It is this decisive moment that is captured in his photography. The 'blacklight' that gives the series its name refers to the technique of using a UV light to draw out the ultraviolet glow of the flowers.

You will need:

camera (digital or analogue),
flower(s), fish tank, water,
glass plates, mirrors,
flash, UV lights, inks, dyes
and paints, syringe

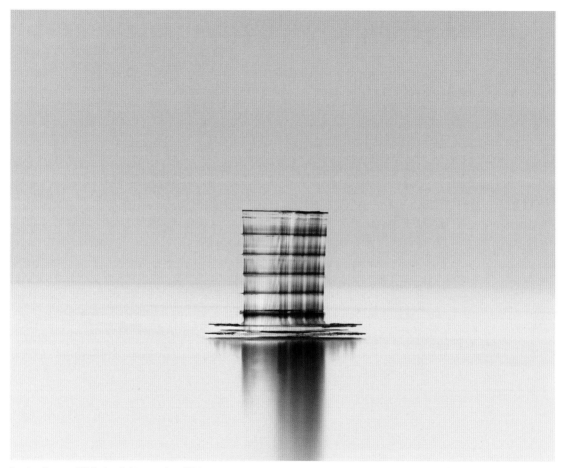

Damion Berger, *S/Y Seahawk, Ligurian Sea, 2014*

Time and motion

Experiment with extremely long exposures

● ● ○

The genesis of Damion Berger's series *Vessels* was night-long exposures of various yachts and cruise ships caught on film as they drifted around their anchor, at the mercy of the ebb and flow of the winds and currents. Using a large-format camera and sheet film, Damion would leave the camera's shutter open at the smallest aperture (f/64) for up to eight or nine hours, to reveal the hidden architecture of the boats' movement.

Printed as negatives, the resulting photographs are like layered line drawings whose geometry traces the passage of a ship's limited motion over the course of a single night at anchor. However, out of the hundreds of nights that he took a photograph, only a fraction of the exposures worked, as it was very much down to chance whether the conditions would be in Damion's favour and deliver the sought-after abstract and architectural island forms he was hoping for.

You will need:

camera, tripod, film

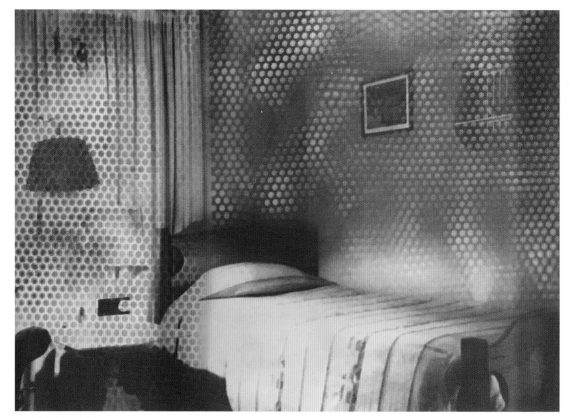

Molly McCall, *Night Light*

Paint and stencils

Handcraft your photo using digital techniques

● ● ○

Artist and photographer Molly McCall creates stencilled images using found photographs that capture 'flaws, imperfections and signs of humanity that convey empathy'. To follow her method, find an image that you want to use, photograph it digitally, and transfer it to your computer to be manipulated in Photoshop. Then follow these steps:

1. Once you are happy with the finished digital image, turn it into a negative using Photoshop and print it onto transparency film.

2. Contact-print this negative in the darkroom onto warm-tone, fibre-based paper. Molly's prints are often toned, using various natural or chemical toners such as sepia or selenium.

3. Once the toned print is dry, paint the image with layers of photographic dyes and acrylic paints, adding layers of texture and diffusion using stencils (either found or made). Finally, give the image a coat of matt varnish to protect it.

You will need:

source image; computer and editing software; printer and transparency film; darkroom and printing paper; toners (optional); dyes, inks and/or paints; stencils; varnish

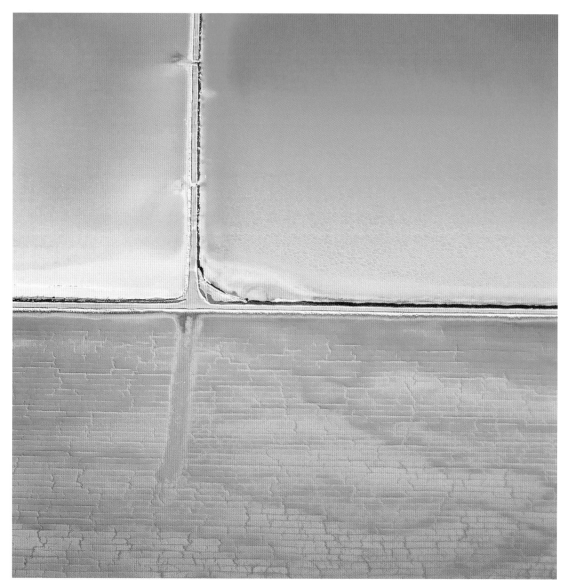

Robert Salisbury, *Useless Loop, Shark Bay*

Aerial abstracts

Capture a scene from the sky

● ● ○

Shooting from the air can give your photographs a whole new perspective, especially if you seek out top-down abstract views of our planet. As photographer Robert Salisbury explains: 'I have found many things viewed from the air to be stunning and akin to a hidden beauty as they just can't be seen from ground level.'

The salt mines in this photograph are a great example of this 'hidden beauty', with the varying degrees of evaporation creating a mixture of tones and textures, and the roads and containing banks providing a contrasting geometric pattern. Taken from a Cesnna 150 aeroplane with the doors removed ('Taking the doors off allows you more movement to position yourself and is also quite exhilarating too!'), Robert relied on wide apertures and fast shutter speeds to battle the vibration from the plane, using auto ISO to give him the settings he needed. The focus was set at infinity and the focus ring taped, as the wind can cause the focus to shift when you point a lens out of the side of the plane.

You will need:

camera, aerial platform (plane, helicopter, drone, kite, balloon, or even a pole)

Do it your way

Shooting from an aeroplane isn't the only option. Camera-equipped drones are becoming ever less expensive, while KAP (kite aerial photography) and BAP (balloon aerial photography) can be explored by the more adventurous. Alternatively, you could find yourself a vantage point in or on a tall building.

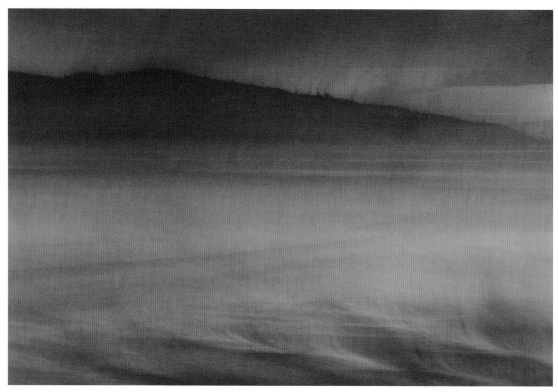

Lynn Fotheringham, *Softly 2*

Shake it!

Move the camera to create blur

● ○ ○

Motion blur can be introduced into an image in one of two ways: either by moving the subject (as is the case with Elena Kulikova's spinning vase of flowers on page 42), or by moving the camera itself. The latter approach was used here by Lynn Fotheringham, a former wallpaper and textile designer who now concentrates on making landscape images in her native north Lancashire and the northwest of Scotland.

Although most of her work is abstract, Lynn still considers focus and the direction and quality of light important: 'Blurring and abstraction can be created in many different ways and I'm always experimenting with new techniques. The simplest way to create blur is to move the camera, but you still have to make sure that the composition of the image conveys a strong message.'

Camera blur can be controlled through a combination of physical movement, which also determines the blur's direction, and exposure time, which determines the extent of the blur. The key exposure control is the shutter speed, so you need to have at least some way of changing it, be it through setting the shutter speed directly, reducing the ISO or using a small aperture; if your camera is fully automatic then try shooting when the light levels are low.

You will need:

camera with exposure control (manual or semi-automated)

Gisela Arnaiz Fassi, *Double Touch*

Cyanotype

Use the sun to print from digital negatives

● ● ○

Vintage processes don't have to look 'old-fashioned', as Argentinian artist Gisela Arnaiz Fassi proves. Starting out with images shot using a digital camera, Gisela uses Photoshop to create a large-format digital negative that she prints out on transparency film. She then takes the digital negative and prints it using the cyanotype process, a printing method dating back to the mid-1800s that was widely used by engineers as a low-cost and straightforward way of copying drawings (the familiar 'blueprint'). In Gisela's case, she creates mirror images of her work to form diptych-like pieces printed onto watercolour paper. How to make a simple cyanotype is outlined on the following pages.

Do it your way

Using a digital negative gives you more control over your final image, but you can create a cyanotype with any object that creates a silhouette. Flowers and plants work particularly well, and plastic bottles can produce a good effect as they vary in levels of transparency. You can also create simple abstract compositions by laying several small objects on the paper in a design of your choosing.

Cyanotype

Cyanotype is one of the oldest and easiest 'alternative' processes to explore, and also one of the least expensive, as there are very few specialist requirements. Indeed, because cyanotypes are so easy (and the process is relatively non-toxic), it's even something that children can do.

If you look online you will find numerous variations on the cyanotype sensitizer formula, but they essentially boil down to the same thing: two solutions consisting of 'green' ferric ammonium citrate and potassium ferricyanide in distilled water. These chemical compounds are relatively easy to come by online, so there's little reason not to experiment with making your own cyanotype sensitizer. You can also buy readymade sensitizers at a massively inflated price (convenience costs more), but in both cases, the actual process is the same.

You will need:

cyanotype sensitizer (mix your own or buy readymade); paper to print on (or card, fabric or similar); glass-coating rod or brush; gloves; contact-printing frame (or 'clip'-style photo frame)

1 If you are making your own sensitizer, you will start with two solutions that need to be mixed together in equal parts.

2 Your solution will be sensitive to UV light, such as sunlight or a UV lamp, so brush it onto your paper or other material in a dark room or at night under artificial lights. Leave the paper to dry in the dark.

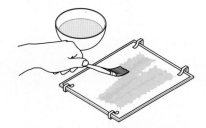

3 Once your paper is dry you are ready to print. If printing from a negative, sandwich the paper and negative in a contact-printing frame or simple 'clip'-style photo frame. You can also place objects such as flowers or leaves directly onto your paper to create photograms.

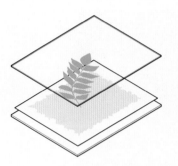

4 To expose your paper/negative, leave it outside in sunlight, or use a UV lamp indoors. Exposure times depend on the intensity of your UV light, but initially the exposed cyanotype will look quite heavy and dark.

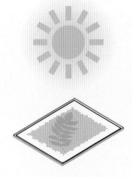

5 Processing the cyanotype is very simple; just run the paper under water and a much lighter image will emerge. Wash for about 20 mins, then remove it and hang it up to dry.

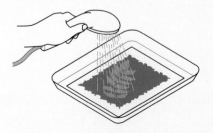

6 Once the print is dry the shadows should have deepened. If things haven't worked out, next time try reducing your exposure time if the print is too dark, or increase it if it is too light.

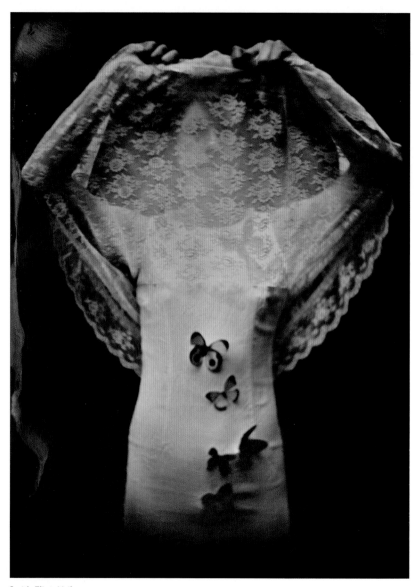

Smith Eliot, *Veil*

Tintype

Experiment with an old 'photo booth' technique

● ● ●

Smith Eliot has been making mixed-media work since the 1980s, working with a number of alternative processes. The tintype (also known as a melainotype or ferrotype) had its heyday in the 1860s and '70s, but with the 21st century comes a refreshing revival of this technique.

A simple tintype is made by creating a direct positive onto a thin sheet of blackened metal. Historically, tintypes were created on iron, but today most tintype photographers use black aluminium engraving stock.

1. The metal plate is first coated with a syrupy mixture containing collodion and salt, then submerged in a bath of silver nitrate; the silver combines with the salt, making the plate light-sensitive.

2. The plate is transferred to a plate holder that fits into the back of a large-format camera and is exposed to light while it is still wet.

3. It is then developed in the darkroom using an iron-based developer and fixed with either traditional fixer or potassium ferricyanide.

Do it your way
Although it uses dry plates instead of wet plates, Rockland Colloid's Tintype Parlour Kit will let you create a pseudo-tintype without worrying about the complexities of wet-plate processing.

You will need:

camera (can also make photograms); suitable plates (iron or aluminium); black enamel (spray paint works); emulsion and developer (look online for recipes to experiment with); darkroom for coating and developing the plates

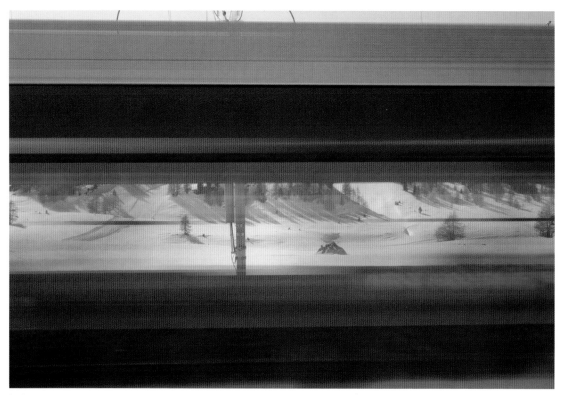

Rolf Sachs, *Camera in Motion 19.03.2013 / 13:28:03*

Speed

Landscape photography from a moving train

● ○ ○

In his series *Camera in Motion: From Chur to Tirano*, Rolf Sachs documents the changing seasons and light using a particular combination of abstraction and photorealism to quite literally 'blur the limits between abstract art and landscape photography'.

This beautiful photograph was taken with a Leica S camera from a moving train, capturing the passing landscape through the windows of another train that was racing by. Because distant objects always seem to pass by at a slower pace than those nearest to us, the apparently static landscape in the distance contrasts sharply with the vibrant train in the foreground. This cinematic image has contrasts of colour (the red and grey of the train against the near-monochrome snowscape), clarity (the sharpness of the landscape versus the blur of the train), and detail (individual trees appear in sharp relief in the distance, while the train is virtually featureless). More pertinently, there is also a perfect balance between the two areas in terms of the amount of picture space they occupy.

You will need:

camera, moving platform
(train, automobile or similar)

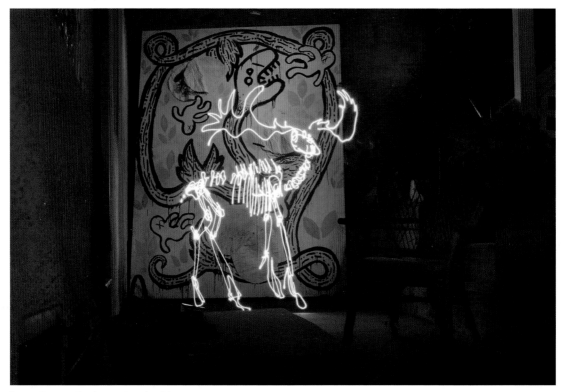

Darren Pearson, *Bambi, Los Angeles, CA*

Light painting
Create light drawings using long exposure

● ● ○

Darren Pearson (aka 'Darius Twin') has dedicated his photographic career to creating life-sized light drawings in a variety of locations. Using a Night-Writer, which is a specialist handheld LED light that he designed himself to create his images, Darren sets up his camera on a tripod, switches it to Bulb mode (for long exposure), opens the shutter, and then steps in front of the lens to draw with light in mid-air. There's a certain amount of trial and error involved, as the finished light drawing is only visible in the resulting photograph, but the beauty of using a digital camera is that you can immediately see what has worked and what has not, and adjust things accordingly.

Although Darren uses his self-made Night-Writer (which he also sells online), regular torches, battery-powered strobes, light wands, or pretty much any other light-emitting source you can think of can be used for light painting, with coloured gels enabling you to colour the light for creative effect. With experience you can even begin to use multiple light sources, as Darren has done here.

You will need:

camera with Bulb (B) setting, tripod, light source (LED Night-Writer, torch, light wand, or similar)

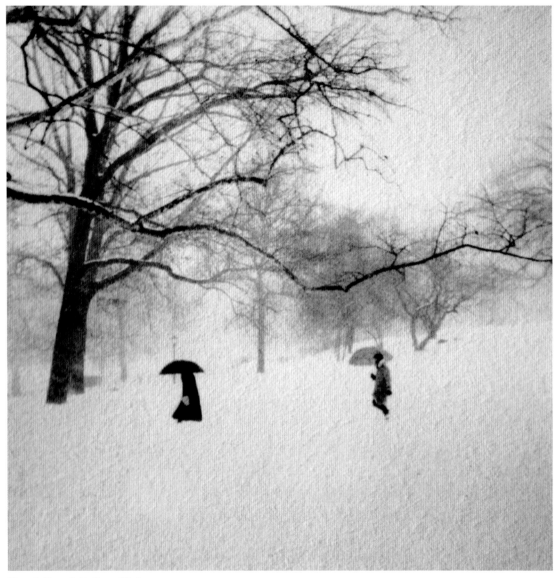

Diana H. Bloomfield, *Central Park*

Split printing

Use two old processes to create an eerie image

● ● ●

Central Park was photographed by Diana H. Bloomfield during the blizzard of 1996, which brought New York to a standstill in January of that year. Many years later, she revisited the image and decided to use a 'split printing' technique incorporating two historic processes: platinum/palladium and gum bichromate. To recreate her process, follow these steps:

1. First, scan your original film and make a large-format digital negative to contact-print with.

2. Print this negative using the platinum/palladium process. This essentially involves creating a photographic emulsion by mixing an iron solution with a platinum and/or palladium solution, which is then coated onto paper, exposed, developed and dried to give a finished print.

3. For this image, Diana then used the same black-and-white digital negative to print a single wash of gum bichromate over the platinum/palladium image. This process – which uses a mix of potassium or ammonium bichromate sensitizer, gum arabic and watercolour pigment – mostly adhered to the trees, adding the golden colouring.

You will need:

Digital negative (same size as your intended print)

For platinum/palladium printing: platinum and/or palladium, ferric oxalate, potassium oxalate, distilled water, EDTA (ethylenediaminetetraacetic acid)

For gum bichromate printing: potassium or ammonium bichromate, gum arabic, watercolour pigment

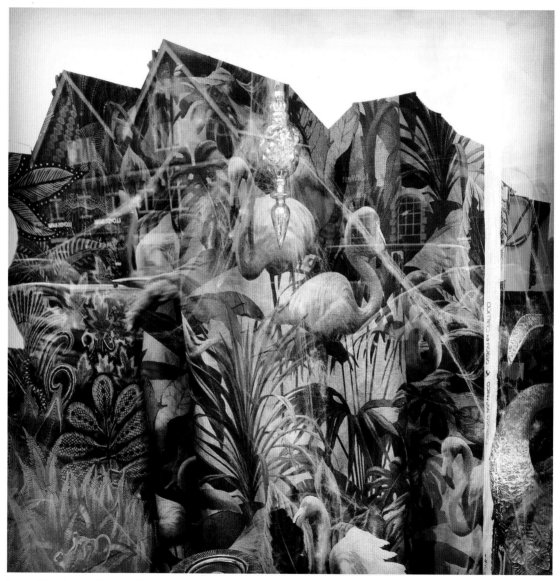

Natalia Price-Cabrera, *House of Flamingos*

Shooting reflections

Cheat the effect of double exposure

● ○ ○

Reflections are often all around us and can produce some exceptionally striking images. It's surprisingly hard to see them as a photograph, though, because our eyes tend to focus either on the elements being reflected, or on the surface reflecting them. With a window, for example, we naturally look through the glass at the objects behind it or focus on distant elements reflected on it – focusing on both simultaneously is usually impossible.

However, as shown by this reflected image, a camera is far better equipped at taking these scenes in its stride. In this case, the brightly coloured fabric in a haberdasher's window combines with a reflected image of buildings on the opposite side of the street. The dark buildings have created a strong graphic shape that contains the bold fabrics, effectively producing what looks like a 'double exposure' in a single shot, forcing the viewer to look harder at what exactly is going on.

More pertinently, you don't need any specialist kit: I shot this on an iPhone, proving that observation can be just as critical as the equipment you use.

You will need:

camera

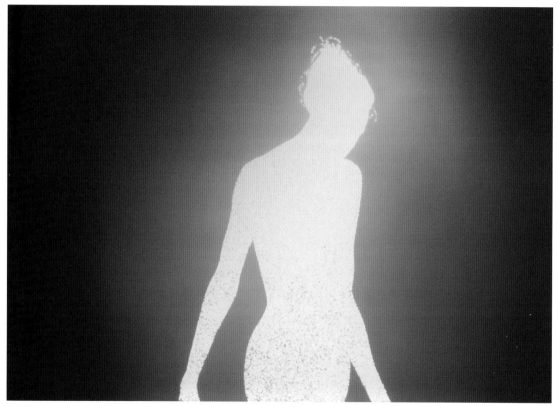

Christopher Bucklow, *Tetrarch*

Giant homemade camera

Create silhouettes using a multiple pinhole technique

● ● ○

Christopher Bucklow's series *Guest* presents 'negative' silhouettes of men and women against backgrounds of colour. The imaging process starts with Chris projecting the shadow of his sitter onto a large sheet of aluminium foil, onto which he traces their outline. He then makes thousands of pinholes within the area of this foil silhouette, effectively creating a multitude of tiny pinhole lenses.

The foil is then put into a homemade device that holds the foil over a large sheet of colour photographic paper. Chris wheels this homemade 'camera' out into daylight and pulls the 'shutter' to expose the foil/paper to daylight. Where the light passes through the multitude of pinhole 'lenses' in the foil the sun is literally being photographed and exposed on the paper beneath, with the intensity of the light and the length of exposure creating unique colour variations in the processed print.

Do it your way
You could easily work on a smaller scale than Chris, creating your multi-pinhole foil shapes from a variety of subjects and printing them onto colour or black-and-white photo paper outdoors or in the darkroom. As with any silhouette, simple, identifiable subjects tend to work best, but don't let this stop you from trying more complex arrangements.

You will need:

aluminium foil, pin/needle to make pinholes (see p.36), photo paper (colour or b&w), pinhole camera/ homemade camera

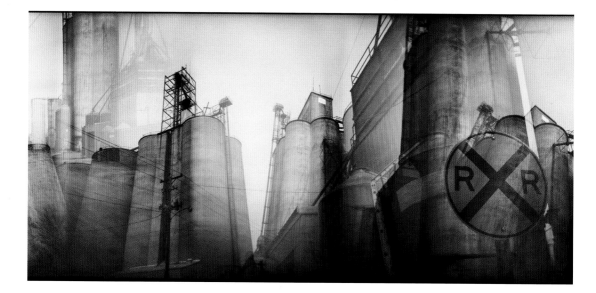

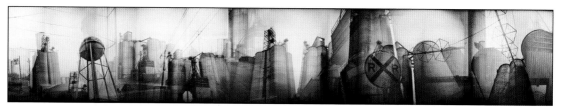

Susan Bowen, *Prairie City Grain Elevator*

Holgaramas

Overlap exposures on an entire roll of film

● ○ ○

The Holga is a fairly ubiquitous and incredibly simple medium-format plastic camera. One of its quirks is that the manual film advance and shutter aren't interlocked, so you don't have to advance the film a full frame before you can shoot again. Although this is responsible for countless 'accidental' overlapping images it can also be intentionally exploited.

This is how Susan Bowen created her agriculture-themed image: by only partially advancing the film between shots, exposures overlap one another, creating an elongated assemblage of layered images that take up an entire roll of film. Because of the length of the image on the film, Susan has to scan the negatives in two sections (using a large flatbed scanner) and then splices them together in Photoshop, where she will also make sure the exposure is even, enhance the colour, and do minor editing. Each image is then cropped to pull out the most interesting section of the original full roll.

You will need:

medium-format
Holga camera;
120-format roll of film;
large flatbed scanner
with transparency unit
in the lid (ideally with
an 11×17in. bed)

Holgaramas

The great thing about Holgaramas is you don't need any specialist kit – you just need a regular Holga loaded with medium-format film. The magic comes from the way you set up and use your plastic camera to create a slightly disjointed panoramic image that reflects the quirky camera's character.

1 Before you load your film, you need to make sure the camera is set to shoot square (6×6cm) images, so if the rectangular (6×4.5cm) mask is in it, take it out.

2 While you're shooting 6×6cm images, you want to wind the film on as if you're taking 6×4.5cm shots, so set the 'winding window' to 16. This simple trick of shooting the larger image size while winding for the smaller one is what will give you the necessary overlap between frames.

3 Load your film as normal and wind it to the start.

4 To shoot your Holgarama, you're going to start at the left of your intended panoramic scene and finish at the right, so line up your first shot in the viewfinder, set the focus and aperture (as if it makes a difference on a Holga!), and take a shot.

5 Turn your camera roughly 45 degrees to the right, which will line up your second shot. Wind the film on to the next frame and shoot.

6 Turn your camera 45 degrees to the right for your third shot, wind the film, and shoot again. Note that you should always work from left to right, otherwise your shots will be back to front (which may be an experiment for another day?).

7 Repeat the 'turn, wind, shoot' sequence until you reach the end of your intended panorama and wind on one extra frame to ensure you don't overlap your next set of shots. You can shoot as many or as few frames in a Holgarama as you like: the more frames you shoot, the more elongated the result will be.

8 When you reach the end of your film it can be taken out of the camera and processed as normal, but be sure to ask the lab to return it uncut – you don't want someone thinking the overlapping frames are a mistake and chopping one of your panoramas in half!

Tips

• Turning your camera through 45 degrees is simply a starting point; the vagaries of a Holga mean that you may need to turn it a little more or less to produce the 'perfect' overlap. Over time you will get a better feel for the distance you need to turn.

• Rather than using the '16-shot' setting on the winding window, you can count the number of 'clicks' as your Holga winds on. Some people reckon that around 30 'clicks' as you wind on will give you a near-seamless panorama (assuming you also turn the camera accurately), but you can also use a deliberately lower number to create a far more 'disjointed' result.

To shoot your Holgarama, start at the left of your scene and work to the right. Shooting square images, but setting your Holga to its '16-shot' setting will provide an overlap between the frames. It's unlikely that your frames will align perfectly (as shown here), but that's an integral part to the process!

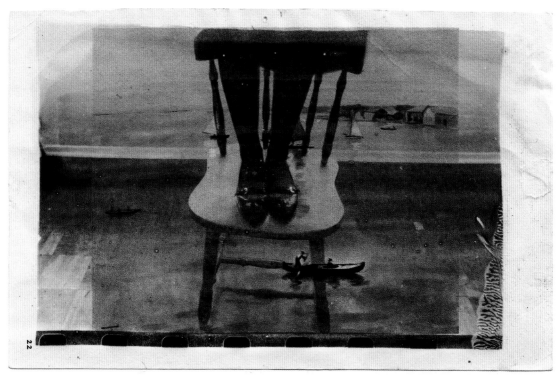

Ashlie Chavez, *The Day After It Happened*

Liquid light

How to print on almost anything

● ● ○

Liquid emulsion (also known as 'liquid light') is a light-sensitive emulsion that you can paint or spread onto any suitable surface, tranforming it into something you can print on. Paper and card stock are obvious choices for this off-the-shelf product, but wood, fabric, stone, metal, and even some ceramics can be printed on with the right preparation. Once coated, you can expose your object in the darkroom, just as you would expose regular black-and-white photographic paper, and process it in the same way as well.

To make this print, Ashlie Chavez painted liquid emulsion onto a print of an image by the French painter Albert Marquet, rather than choosing a 'blank' substrate. She then exposed a self-portrait onto it, effectively creating a double exposure that combined her work with Marquet's. As Ashlie explains, 'Liquid emulsion makes it possible to print on almost anything, making way for infinite ideas to be combined.'

You will need:

darkroom, liquid emulsion, material to print onto

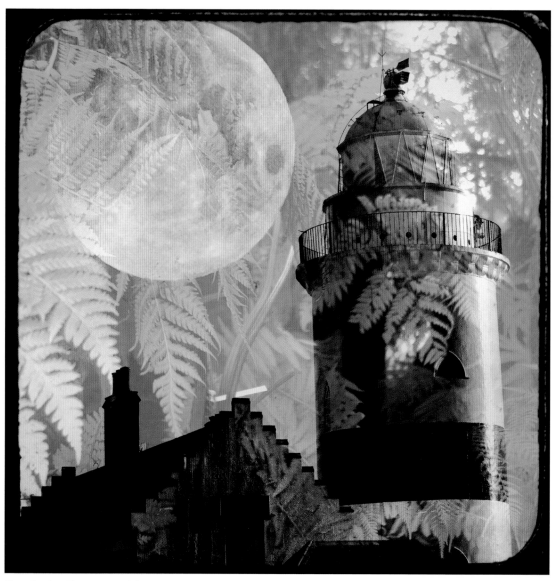

Claire Quigley, *The Botanic Lighthouse*

Digital palimpsest
Superimpose several unrelated images

● ● ○

Bringing disparate elements together to create an entirely new image is by no means a new thing, but it still offers photographers a hugely creative platform with which to experiment. This image was created by Claire Quigley a few years ago when she was writing a series of poems with accompanying photos for a project on Britain during catastrophic sea level rises. It is a combination of four digital photographs layered on top of each other in Photoshop: a full moon; Cloch lighthouse in Gourock, Scotland; some ferns in the Kibble Palace at Glasgow's Botanic Gardens; and a blank TTV shot through a Kodak Duaflex camera (see page 85).

The key to layering images successfully is in your choice of 'blending modes'. Any good software that allows you to layer images will also let you choose how they blend together and react with one another; whether dark elements become transparent and let underlying layers to show through, for example, or whether colours change depending on what they are layered with. You should also be able to control the opacity of your layers, to make them more or less translucent; this adds another level of control over your composites.

You will need:

images, editing
software with layers
and blending modes

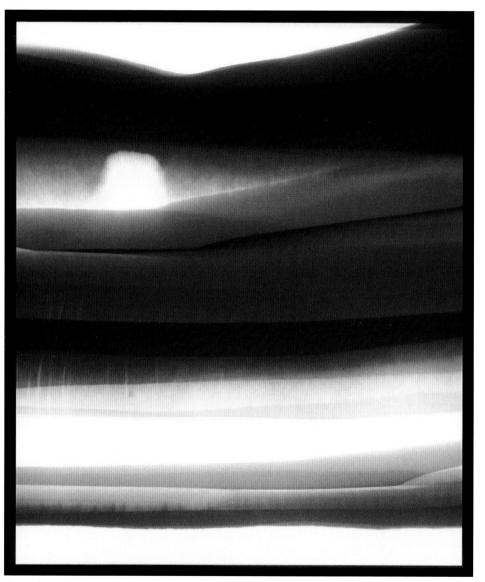

Christopher James, *Solargraph #30, 1971*

Solorgraphs

Printing in sunlight

● ● ○

Some people think you need a lot of equipment to be a photographer, or a darkroom if you want to make your own prints, but this abstract landscape image by Christopher James was created with neither. In graduate school at Rhode Island School of Design, the now artist–professor worked like a painter, rather than a photographer, to create his photographs. 'My "paints" were straight and modified concoctions of traditional black-and-white chemistry, brush applied on black-and-white silver-gelatin papers in sunlight. No darkroom was required. These images were the beginning of my making marks with light and chemistry, and creating images employing alternative photographic processes.'

1. Remove a sheet of black-and-white photographic paper from its light-tight box or sleeve in darkness. Re-seal the package and adhere the sheet, in the light, to a sheet of glass or Plexiglas.

2. Head outside with your paper, brushes, chemistry (straight or modified developer, stop bath and fixer) and in sunlight, proceed to paint, dunk, drip and spray.

3. As soon as you see forms and marks that please you, you can stop all action with an immersion in fixer, or apply stop or fix with a brush. Experiment and see the range of colours possible with simple black-and-white materials in sunlight.

You will need:

black-and-white photographic paper in original packaging; black-and-white chemistry: paper developer, rapid fixer, stop bath, paintbrushes, spray bottle, paper towels; trays for water, fixer and other straight or modified chemistry

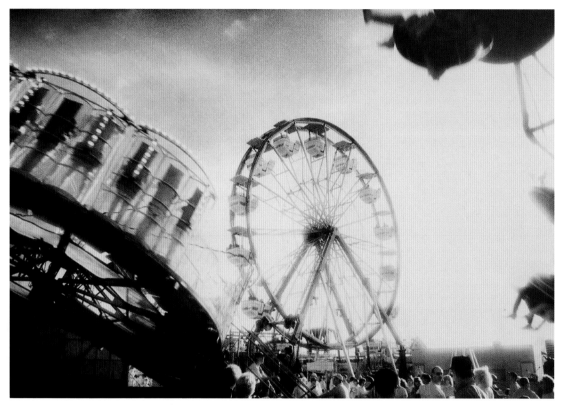

Diana H. Bloomfield, *Midway Rides*

Faking nostalgia

Hand-tint your images to emulate a vintage look

● ○ ○

This photograph was taken at the North Carolina State Fair by Diana H. Bloomfield and is from an ongoing series, *The Midway*. Diana is a photographic artist who specializes in 19th-century printing techniques and she started shooting this series in 1998. 'I started this series because I wanted to create a vision, on paper, of the way I remembered the fair as a child – at once scary, exciting, familiar and foreign, full of colour, wonder and strangeness – and make those memories a tangible paper dreamland.'

To create her 'dreamy' look, Diana shot her photographs on 35mm black-and-white infrared film, which responds differently to light compared to regular black-and-white film. In the darkroom, the photographs were printed onto regular 16×20in. fibre-based paper. The dried prints were then hand-coloured using transparent oil colours specifically designed for tinting black-and-white photographs. Cotton balls and cotton buds were used to apply the oils, creating a faded, old-fashioned, postcard-type effect.

You will need:

infrared b&w film (or regular b&w film), darkroom, photographic paper for printing, photographic dyes for colouring

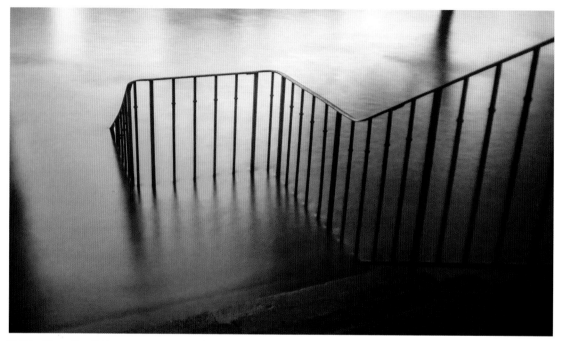

Mathieu Stern, *River Seine*

Improvised filter

Make a misty scene using welding glass

● ● ○

Photographer, filmmaker and teacher Mathieu Stern is known as the 'Weird Lens Guru' online, thanks to his love of vintage lenses and seemingly endless passion for experimenting with photographic techniques. He took this shot of the Seine in Paris using welding glass as an improvised 'extreme' ND (neutral density) filter, lending the river an almost mistlike appearance.

The role of a standard ND filter is to reduce the amount of light passing through the lens. This is useful for a variety of reasons, including when you want to blur anything that's moving in a shot, such as people, water or vehicles. This can be used to good effect to simplify a scene and create more graphic, abstract images; with people and vehicles, a long enough exposure can effectively make them disappear from the shot altogether.

The downside is that the strongest ND filters are expensive, which isn't great if you're on a tight budget or simply want to give the technique a go. However, for a reasonably small outlay you can try out this technique using welding glass, as outlined on the following pages.

Welding glass filters

Shooting through welding glass is no different to shooting through an 'extreme' photographic neutral density (ND) filter, and the same basic problems apply. The biggest of these is the darkness of the glass: you're not going to be able to see what you're shooting and the camera's autofocus is going to have a really hard time getting a lock (if, indeed, it works at all). Once you've got your shots, you will also have to deal with some particularly gnarly colour issues. Here's how to battle your way through it:

1 Unless you deliberately want to introduce creative blur (and a lot of it!), you need to have your camera mounted on a tripod.

2 Without the welding glass over your lens, frame your shot and focus manually. This will ensure the focus doesn't change.

3 Take an exposure reading and set the exposure manually. Then, increase the shutter speed based on the density of your glass (see panel). If the extended exposure time exceeds your camera's longest setting, switch to Bulb mode.

4 Position your welding glass over the lens: a couple of rubber bands around the glass and camera should hold it in place.

5 Take your shot. Use a remote shutter release to fire the camera, holding the shutter open for the duration of your exposure if you're shooting in Bulb mode.

Glass density

Welding glass comes in a range of 'strengths', and before you can work out your exposures you need to determine how many stops of light it blocks. The simple way of doing this is to set your camera up on a tripod and follow these steps:

1 Set the camera to Aperture Priority mode.

2 Dial in a high ISO (ISO 6400 or higher).

3 Select an aperture that gives you the camera's fastest shutter speed (increase the ISO if necessary).

4 Make a note of the exposure (for example ISO 6400, $1/4000$ sec., f/4).

5 Hold your welding glass over the lens and, without moving the camera or changing any of the settings, read off the new shutter speed.

6 The difference between the two shutter speed values gives you your welding glass density in stops. For example, if your shutter speed is $1/4000$ sec. without the glass and $1/4$ sec. with, that's a 10-stop difference. When you use your glass, simply increase the exposure by 10 stops from an 'unfiltered' light reading.

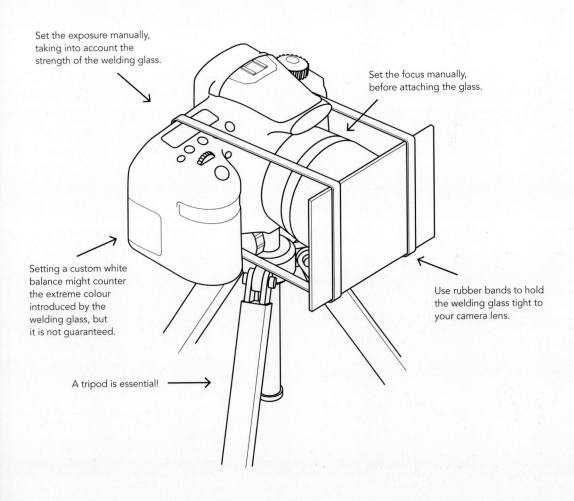

Set the exposure manually, taking into account the strength of the welding glass.

Set the focus manually, before attaching the glass.

Setting a custom white balance might counter the extreme colour introduced by the welding glass, but it is not guaranteed.

Use rubber bands to hold the welding glass tight to your camera lens.

A tripod is essential!

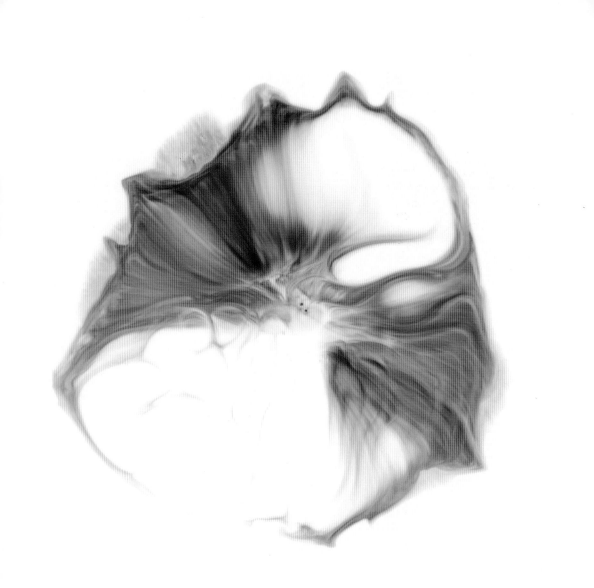

Charles Emerson, *Blood/Milk – Phase III*

Fluid interplay

Create random works of art using milk with other liquids

● ● ○

The simple act of adding one fluid to another and seeing and recording what happens next can produce incredible abstract photographs. The image shown here is by fine art photographer Charles Emerson, whose series *Blood/Milk* uses (yes, you guessed it) blood dropped into milk. To create this piece Charles added an anticoagulant to make sure the blood remained fluid and injected it into a circular milk-filled Petri dish. The fluids combined in a dynamic explosion of movement, creating an ever-changing and completely unique pattern that Charles captured on camera.

You will need:

camera, milk (or water), blood (or paint, ink, dyes, or similar), anticoagulant (optional), dish for liquid

Do it your way

Charles drops blood into milk, but there are plenty of other less extreme options, although the viscosity of the two fluids you use can affect the way that they interact. You could use water instead of milk, for example, and into this drop paint, ink, dyes, or some other coloured fluid – dropping milk into water is a great way of creating a 'swirling cloud' effect.

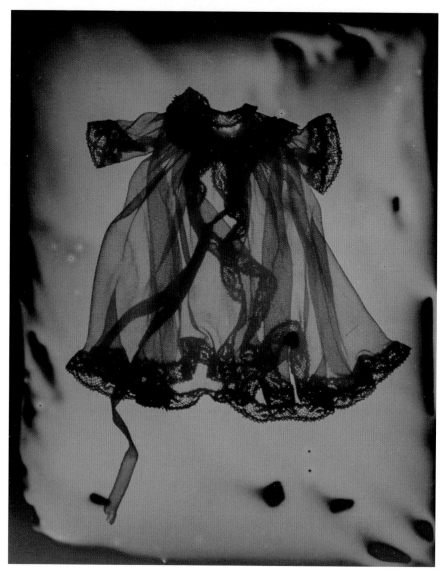

Susan Seubert, *Dressing Gown*
2005. Dry plate tintype, 10×8″. Variable edition of 5

Photogram

Try modern ideas with this old technique

● ● ○

A photogram is often one of the first exercises you will do when you start learning how to use a darkroom, as it simply involves making a print by placing objects onto light-sensitive paper and exposing them to light. The technique became particularly fashionable in the early 1920s, when artist Man Ray refined the technique to such an extent that the new prints eventually became known as 'rayographs'.

Susan Seubert's images of dolls' and children's dresses have been taken a step further by combining photograms with the traditional 'tintype' process, as outlined on page 107, which makes them appear to have an astonishing amount of volume. The distressed and runny emulsion makes the plates look antique and adds a painterly quality to the print surface. Because the dress material is translucent, the images also have the qualities of an x-ray.

You will need:

tintype plates (make your own or buy readymade, as outlined on p.107), objects to place on top of the plate to create a photogram

Adam Fuss, *Untitled*

Daguerreotype

Take time with this time-honoured process

• • •

Adam Fuss is renowned for his contemporary interpretation of early photographic techniques, including daguerreotype, which in essence is a unique image recorded onto a silver-plated copper sheet. Online tutorials for this labour-intensive process are available, but the basic steps are outlined below.

1. A daguerreotype cannot be enlarged, so your final image will be the size of the plate you start with, which in turn will be determined by the camera you are using: the bigger the camera, the bigger the plate, and the bigger the image. Contemporary practices make possible daguerreotypes of contact-printed images.

2. To make your plate, take your silver-plated copper or brass sheet and polish it to a mirror finish. Under darkroom safelight, it then needs to be exposed to iodine vapour (and bromine vapour for increased sensitivity), which react with the silver to create light-sensitive silver iodide. This plate is essentially your 'film', which can be loaded into a camera so you can make your exposure.

3. Once exposed, the plate is 'developed' using mercury vapour in the traditional method or in red-light using the safer Becquerel method, revealing the latent image. The plate can then be fixed, rinsed and dried. The resulting plates are very fragile, so need to be framed behind glass to protect against physical damage, and to isolate the plate from reactive chemicals in the air.

You will need:

camera; silver-plated copper sheets; sensitizing box; iodine (and a means of vapourizing it); mercury (and a means of vapourizing it); sodium thiosulfate (to fix the image); frame/mount

Caution

Working with daguerreotype involves some highly toxic processes, so should not be undertaken lightly; the fumes created and used can cause serious harm.

Artist credits

María Aparicio Puentes *(pages 62–63)*
mariaaparaiciopuentes.com

Gisela Arnaiz Fassi *(pages 102–103)*
gigidamourart.com

Bill Armstrong *(pages 10–11)*
billarmstrongphotography.com

Damion Berger *(pages 76–77, 94–95)*
damionberger.com

Frances Berry *(pages 26–27)*
whereisfrances.com

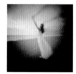

Diana Hooper Bloomfield
(pages 34–35, 112–113, 128–129)
dhbloomfield.com

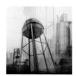

Susan Bowen *(pages 118–119)*
susanbowenphoto.com

Christopher Bucklow *(pages 116–117)*
chrisbucklow.com

Patty Carroll *(pages 14–15, 64–65)*
pattycarroll.com

Ashlie Chavez *(pages 122–123)*
ashliechavez.com

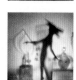

Heidi Clapp-Temple *(pages 44–45)*
heidiclapptemple.com

Etienne Clément *(pages 82–83)*
© Etienne Clément
etienneclement.com

Ben Cottingham *(pages 50–51)*
© Benj Cottingham
Instagram: @benjcottingham

Harold Davis *(pages 74–75)*
© Harold Davis
digitalfieldguide.com

Marcus DeSieno *(pages 24–25, 48–49)*
marcusdesieno.com

Smith Eliot *(pages 72–73, 106–107)*
smitheliot.com

Charles Emerson *(pages 92–93, 134–135)*
charlesemerson.co.uk

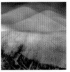

Lynn Fotheringham
(pages 18–19, 100–101)
whatshouldido.co.uk

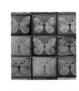

Adam Fuss *(pages 138–139)*
© Adam Fuss, courtesy of
Cheim & Read, New York
cheimread.com/artists/adam-fuss

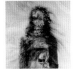

Angélica García Pulido *(pages 58–59)*
© Angélica García Pulido
cargocollective.com/angelicagarcia
angelicagarciafoto.tumblr.com

Tierney Gearon *(pages 88–89)*
Photographer: Tierney Gearon
Epilogue archival pigment print
© Tierney Gearon
tierneygearon.com

Daniel Gordon *(pages 28–29)*
Courtesy of the artist.
© Daniel Gordon 2013
danielgordonstudio.com

Cig Harvey *(pages 54–55)*
© Cig Harvey
cigharvey.com

Christopher James *(pages 126–127)*
christopherjames-studio.com

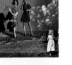
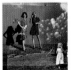

Chris Keeney *(pages 66–67, 84–85)*
© Chris Keeney Photography
chriskeeney.com

Elizabeth Opalenik *(pages 60–61)*
© Elizabeth Opalenik
elizabethopalenik.com

Elena Kulikova *(pages 32–33, 42–43)*
Photography by Elena Kulikova
elenakulikova.com

Brendan Pattengale *(pages 16–17)*
© Brendan Pattengale
brendanpattengale.com

Kim Leuenberger *(pages 12–13)*
kimou.co

Darren Pearson *(pages 110–111)*
Darren Pearson/@dariustwin
dariustwin.com

Daniel Lih *(pages 22–23)*
daniel-lih.com

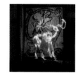

Robert Pereira Hind *(pages 78–79)*
robertpereirahind.com

Molly McCall *(pages 96–97)*
mollymccall.com

Natalia Price-Cabrera *(pages 114–115)*
Instagram: @maximalist_girl

Kat Moser *(pages 46–47)*
© Kat Moser
katmoser.com

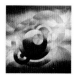

Claire Quigley *(pages 38–39, 124–125)*
clairequigley.net

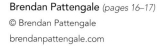

 Mario Rossi *(pages 30–31)*

oiramphoto.com

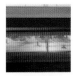 **David Ryle** *(pages 80–81)*

David Ryle – Photographer; Gemma
Fletcher – Art Direction; Natasha Freeman –
Styling; Ellie Tobin – Hair & Makeup

davidryle.com

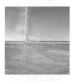 **Rolf Sachs** *(pages 108–109)*

Photograph by Rolf Sachs & Daniel
Martinek | Courtesy Rolf Sachs

rolfsachs.com

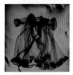 **Robert Salisbury** *(pages 98–99)*

robertsalisbury.photography

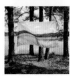 **Susan Seubert** *(pages 136–137)*

Photographs @ Susan Seubert.
Images courtesy of the Froelick Gallery

seubertfineart.com

Keith Sharp *(pages 56–57)*

Courtesy Keith Sharp

keithsharp.net

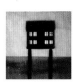 **Jennifer Shaw** *(pages 90–91)*

jennifershaw.net

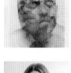 **David Samuel Stern** *(pages 40–41)*

davidsamuelstern.com

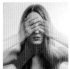 **Mathieu Stern** *(pages 68–69, 130–131)*

mathieustern.com

 Naomi Vona *(pages 8–9)*

saatchiart.com/naomivona

Acknowledgements

First and foremost I must thank Zara Larcombe, Commissioning Editor at Laurence King Publishing, for entrusting me with this fascinating and much-overdue collection of creative contemporary photography. As a dear friend and long-time professional colleague, it has been an honour putting this book together for you. Your vision and creativity knows no bounds and you have always been, and I expect will always be an incredible source of inspiration. Big hugs lovely. To my Editor, Felicity Maunder, at LKP, thank you for all your endless hard work. You have been an absolute pleasure to work with and your attention to detail and creative input has been a true delight.

Thank you to all the contributing photographers and artists who gave so generously of their time, knowledge and images. You have all been an inspiration and this book is an accolade to your extraordinary creativity. I just hope it reflects the considerable admiration I have for your collective output. Thanks too must go to your assistants, studio managers and gallery representatives who have bent over backwards to help me with endless questions, requests and nagging emails. Your time and patience have been crucial in bringing this book together.

Thank you to my family. To my beautiful, creative and inspiring children – Tatiana, Georgia-Mae and Harper – you keep me on my toes, but I wouldn't have it any other way. And to my better half Chris, you rock my world with your love, support and friendship. I love you my darlings, even though you call me old baggage and take no notice of anything I say!

Image credits

page 21 (tiles): © Jo Way-Young
page 71 (flowers): © Jo Way-Young
page 121 (cityscape): © Darwinsm81 | Stock Free Images